MUSCLES IN MOTION

FIGURE DRAWING FOR THE COMIC BOOK ARTIST

Glenn Fabry

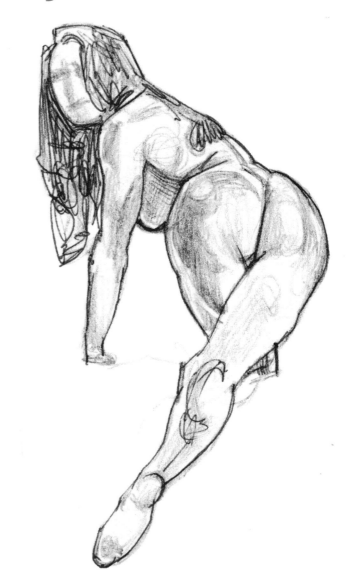

D1295501

MUSCLES

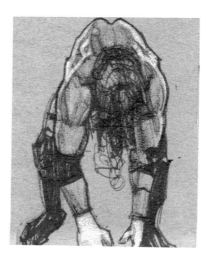

N MOTION

FIGURE DRAWING FOR THE COMIC BOOK ARTIST

Glenn Fabry

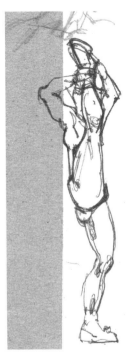

Watson-Guptill Publications / New York

Senior Editor: Jacqueline Ching
Production Manager: Hector Campbell
Book Design: Maria Cabardo and John Pinsky

First published in 2005 in the United States by
Watson-Guptill Publications, a division of VNU Business Media, Inc.,
770 Broadway, New York, NY 10003
www.wgpub.com

Library of Congress Cataloging-in-Publication Data

Fabry, Glenn.
Muscles in motion : figure drawing for the comic book artist / by Glenn Fabry.
 p. cm.
Includes bibliographical references and index.
ISBN 0-8230-3145-4 (alk. paper)
1. Anatomy, Artistic. 2. Figure drawing--Technique. 3. Comic books,
strips, etc.--Technique. I. Title.
NC760.F225 2005
741.5--dc22

 2005004561

This book was set in Trade Gothic.

Printed in the U.S.A.
First printing, 2005
2 3 4 5 6 7 8 9 / 12 11 10 09 08 07 06 05

Dedicated to Kitty, Tom and Nikki

Warming Up

The drawings in the first part of this book were done as a kind of exercise. I'd read an interview with a well-known comic book artist whom I admire, Steve Rude. He mentioned that before getting down to work, he would limber up by doing some drawings for his sketchbook. I thought, What a great idea! Push ups with a pencil! Sketches for stretches! Sketching and doodling is fun. You can access the creative side of your brain and get the ideas coming in.

Also, at the end of the day, you'd have something to refer to that you could use to help you with the finished work.

These drawings were done for a more practical purpose, too. I wanted to depict how the human figure looks in action. In my comic book work, it is important to be able to draw anatomy convincingly.

For five minutes a day, I would practice getting used to drawing the human figure in action, and at the same time, I created a library of reference material.

I ended up taking the sketches too seriously, however, and soon I was spending over an hour a day on them. I had to cut back or risk missing deadlines.

Keep a sketchbook. Some of your best ideas will come from it. And there's no pressure to perform with a sketchbook. There are no expectations. A sketchbook is like a playroom. (Unfortunately, my playroom is full of superheroes, and they've chucked me out.)

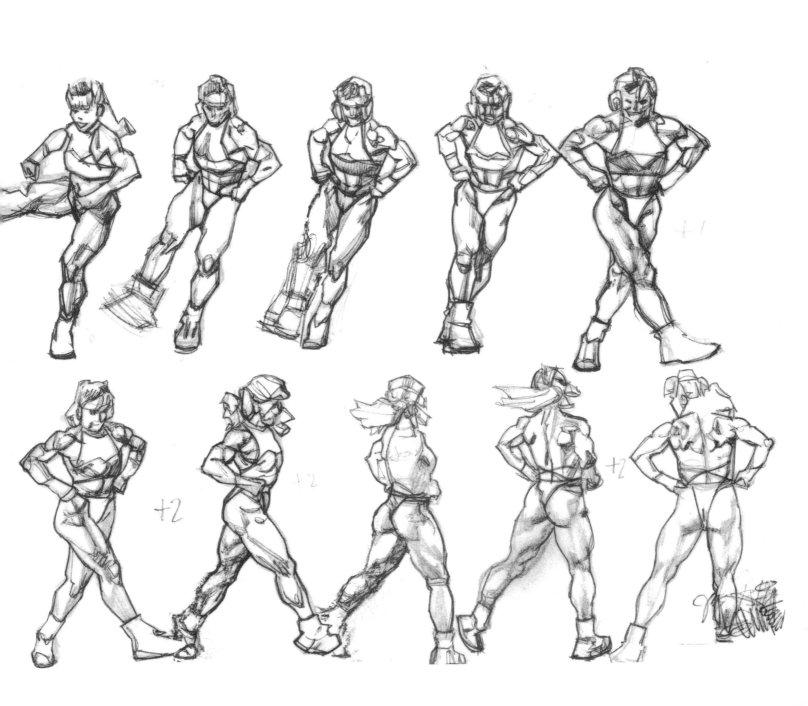

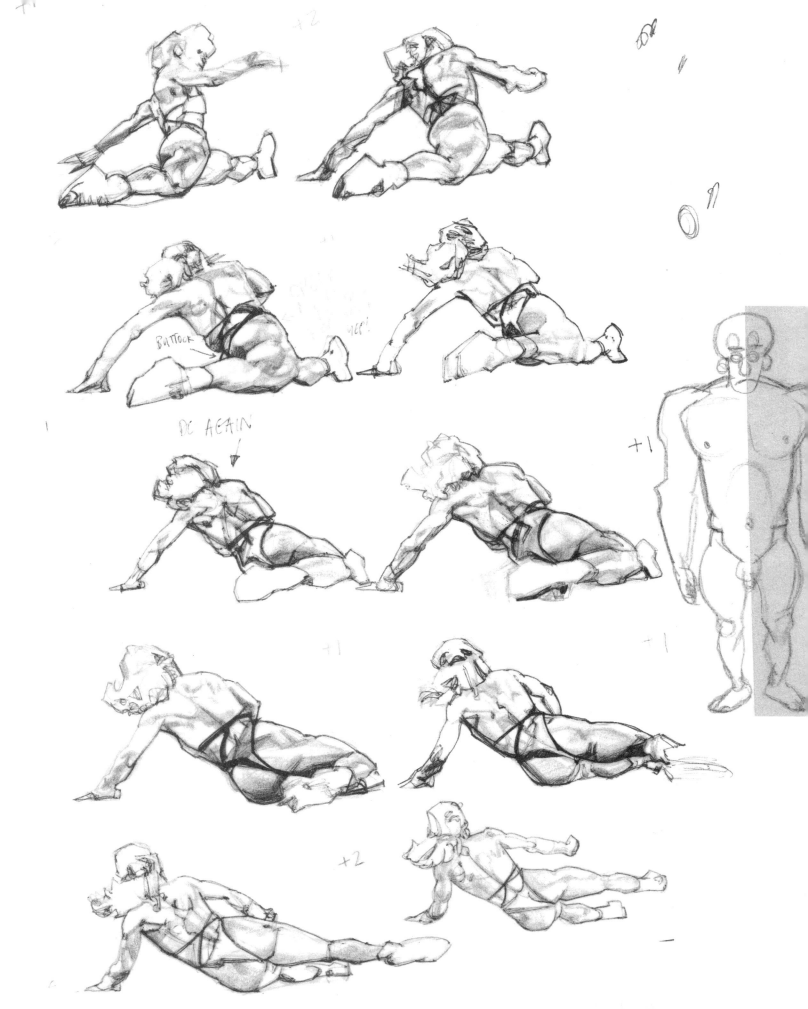

BUTTOCK

DC AGAIN

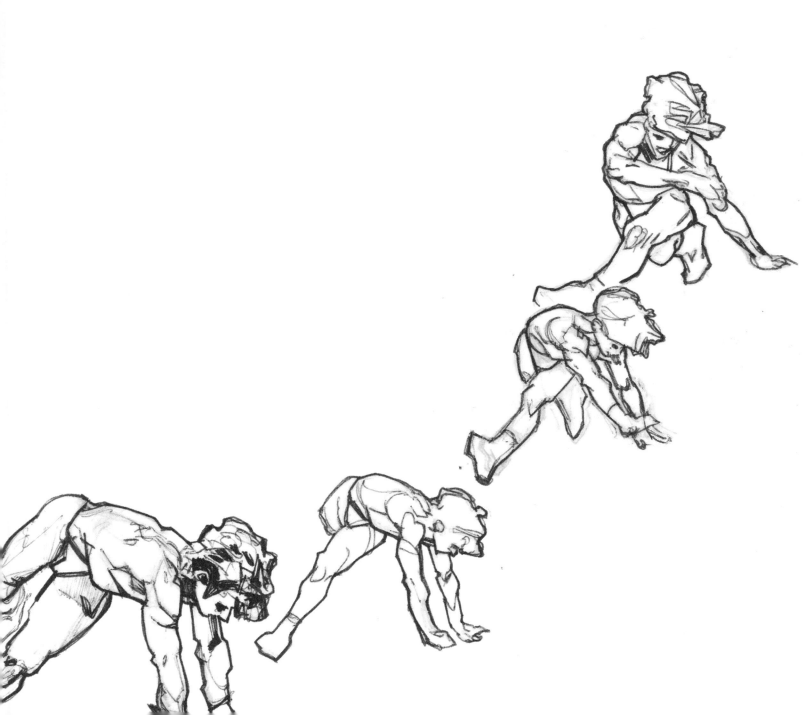

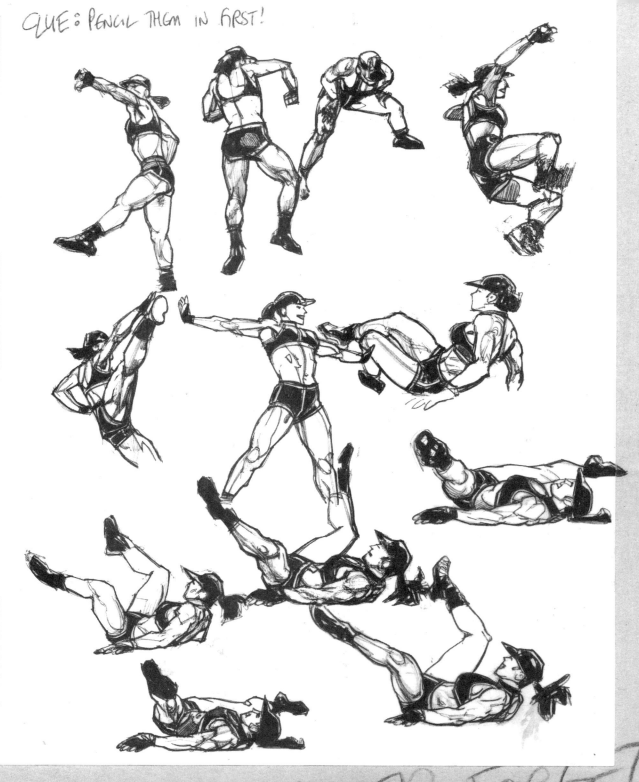

CLUE: PENCIL THEM IN FIRST!

NEVER FORGET-
RYTHUM!
REMEMBER MARY CAINE!

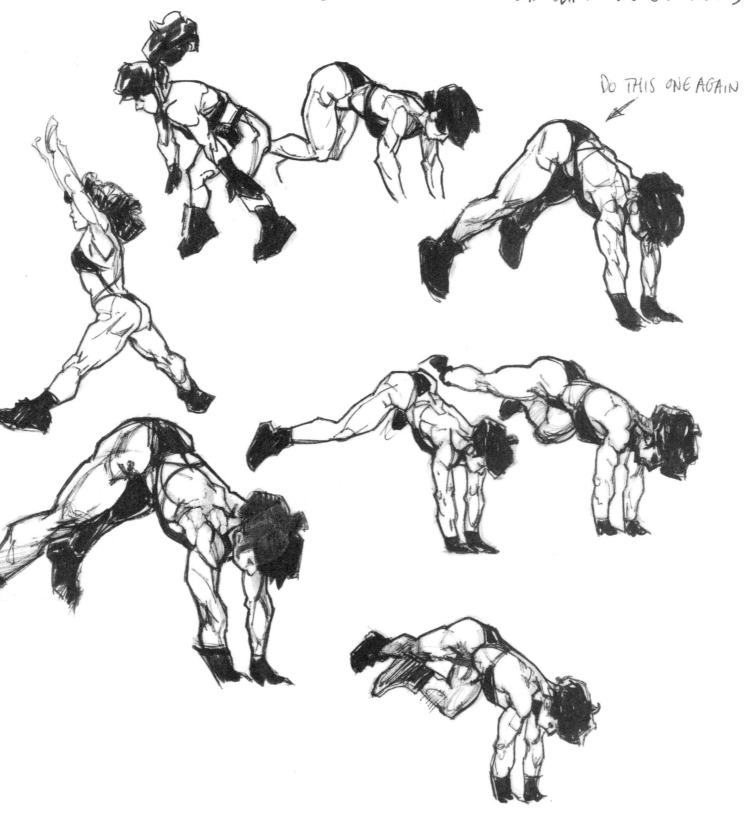

ACTUALLY, LOOKS BETTER WHITE.

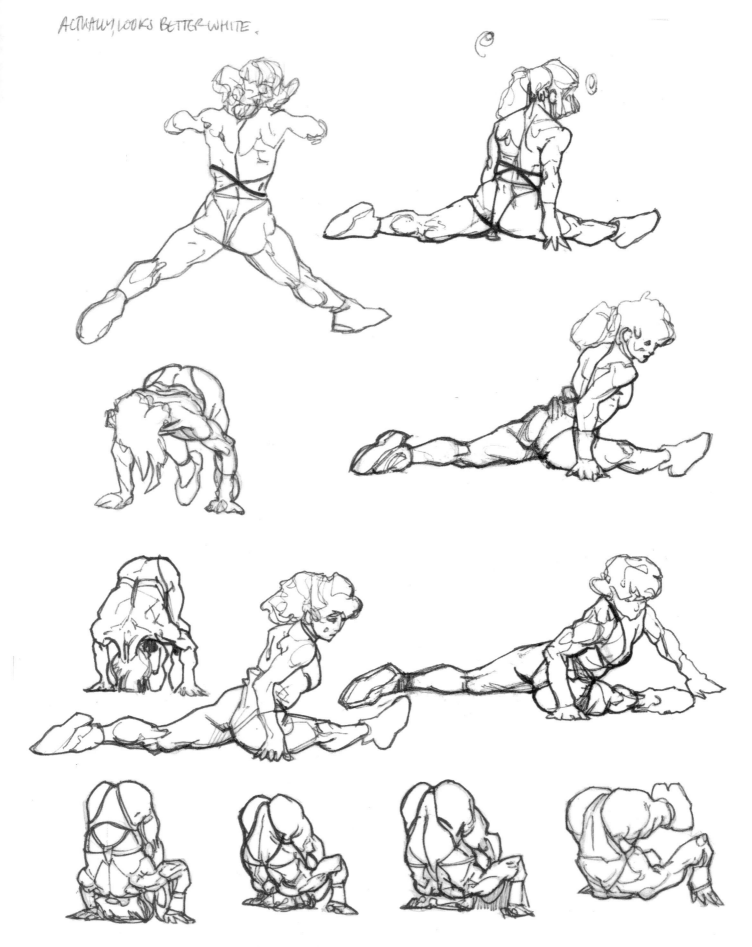

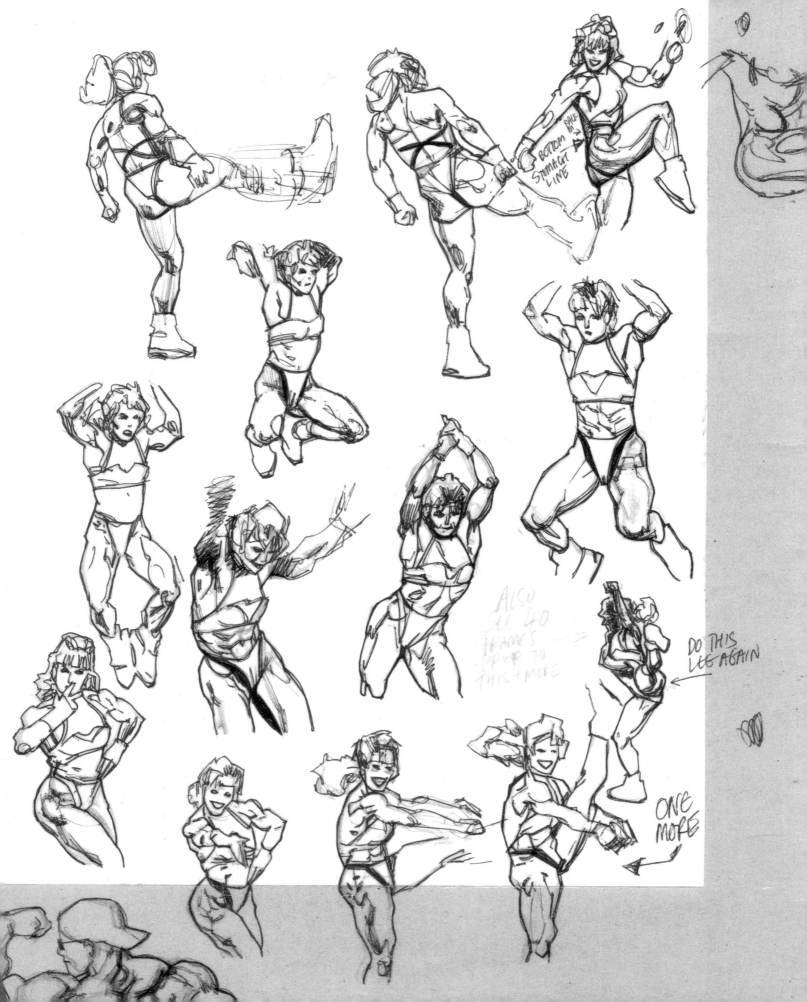

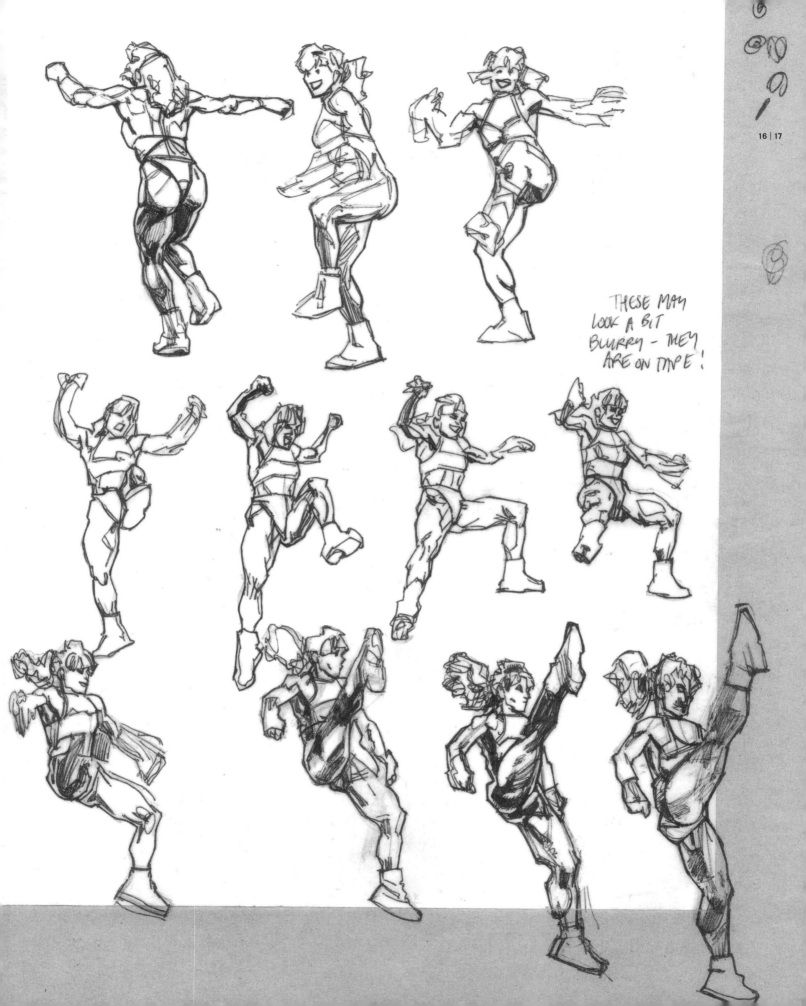

THESE MAY
LOOK A BIT
BLURRY - THEY
ARE ON TAPE!

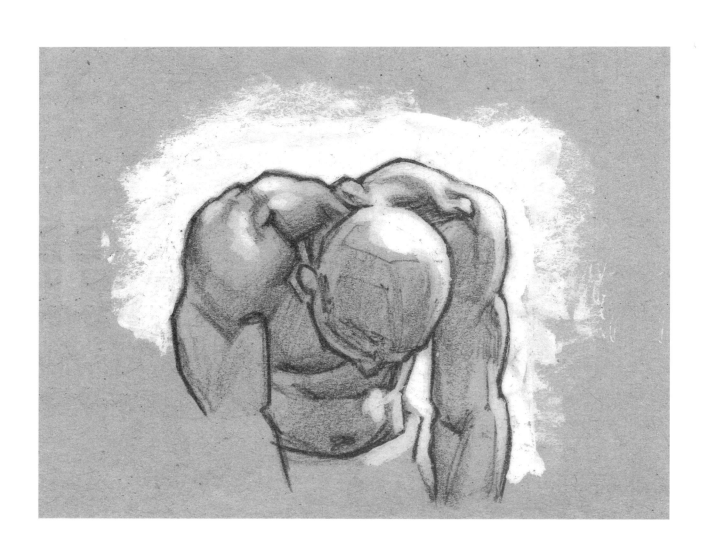

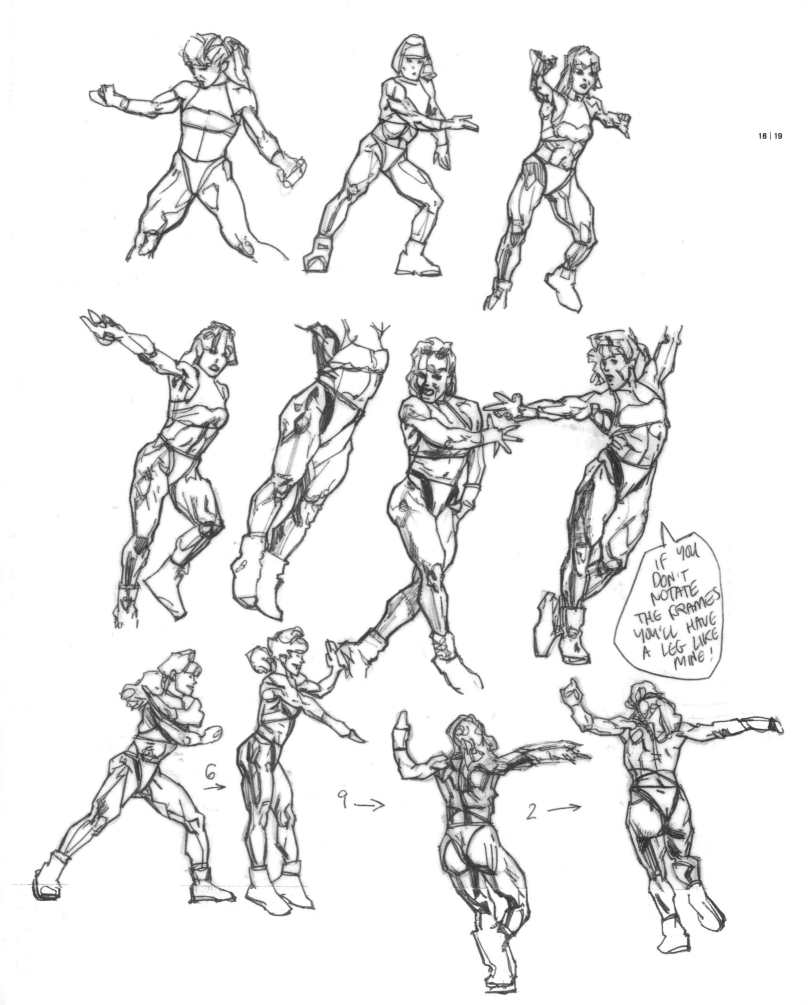

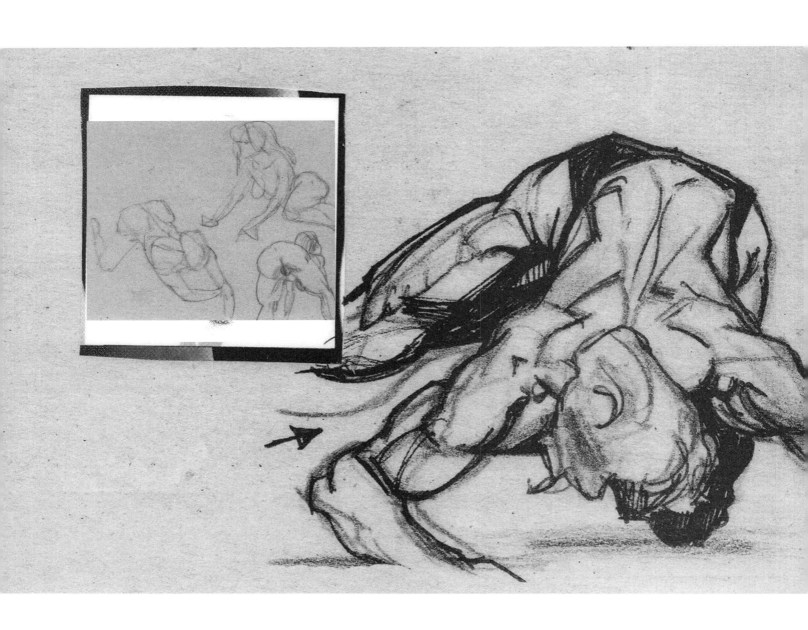

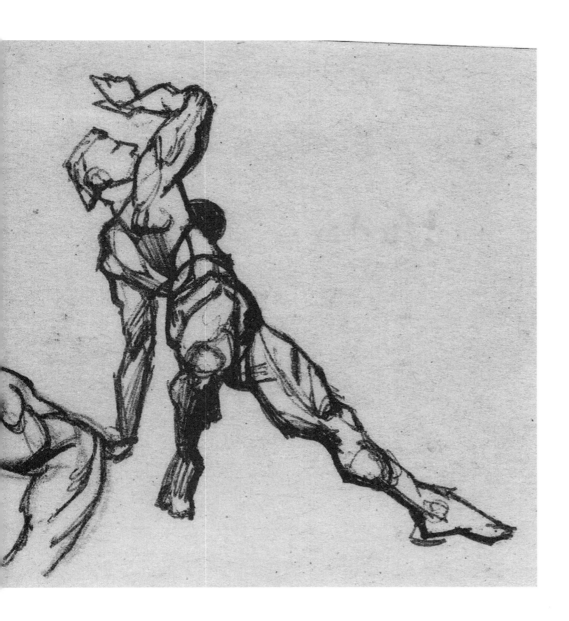

Structure

When drawing the realistic human figure, bear in mind that what is holding the whole thing up is the skeleton. The skeleton is the solid frame that supports the rest of the body. The muscles, fat, cartilage, skin, all adjust according to the way the skeleton is positioned. If you hold your arm straight in front of you while facing a mirror, then rotate your wrist from side to side, you can see that the whole shape of the arm changes, and that the muscles in your chest react too.

So when you're drawing, especially if you're not using reference, draw the skeleton first, however roughly. That becomes your frame.

I call this the structural approach to drawing: You start with the bones, add the flesh, add the clothes and the hair, and finish off with the light in the eyes and the nail polish.

When sketching in the skeleton, very rough shapes will do. On the head, mark the line of the eyes. Note the position of the ears. Roughly indicate where the ribcage and the hips will be. On the ribcage, establish where the lines of the spine and sternum would be, and on the hips, where the iliac crests and the coccyx would appear.

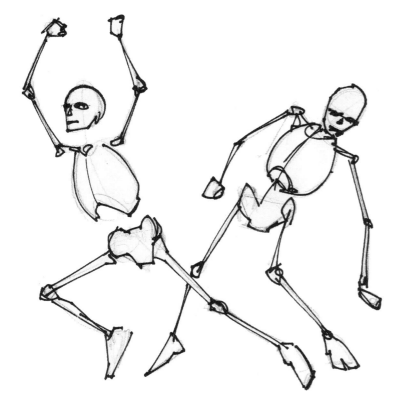

This is a good way to begin a figure drawing, whether or not you are using reference. I call it the skull-chest-hips method. Loosely block in where these three elements of the figure are to be placed.

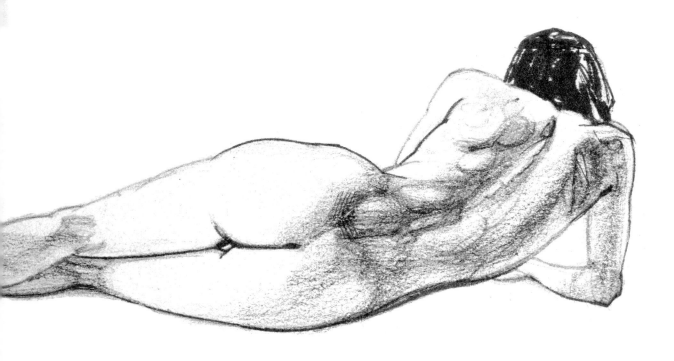

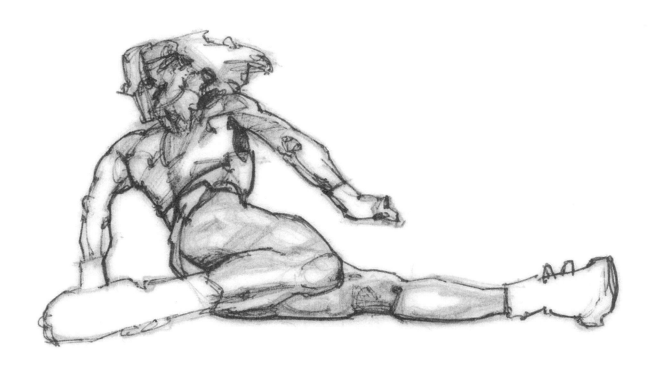

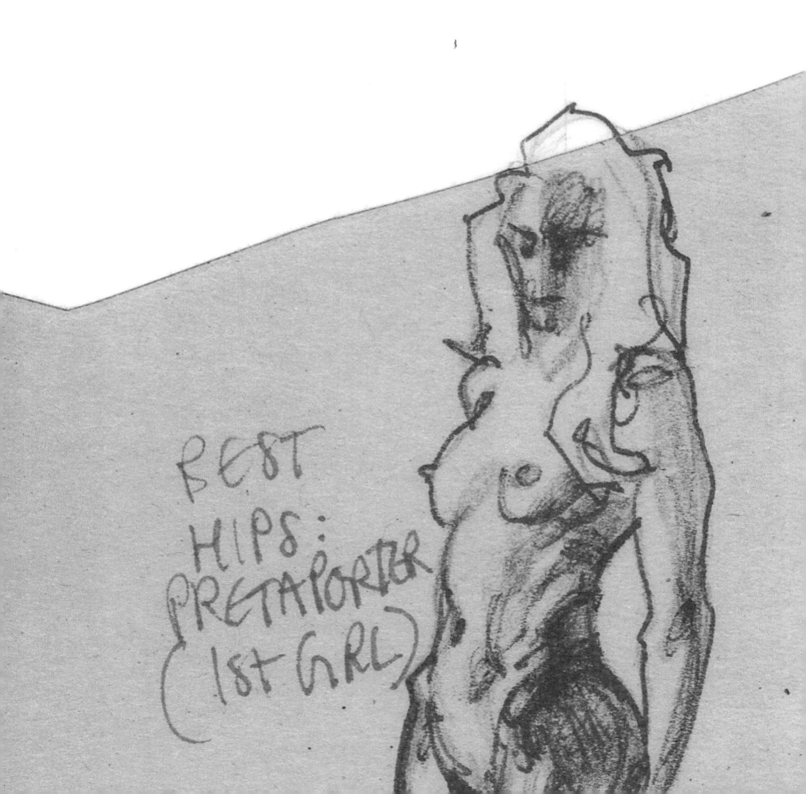

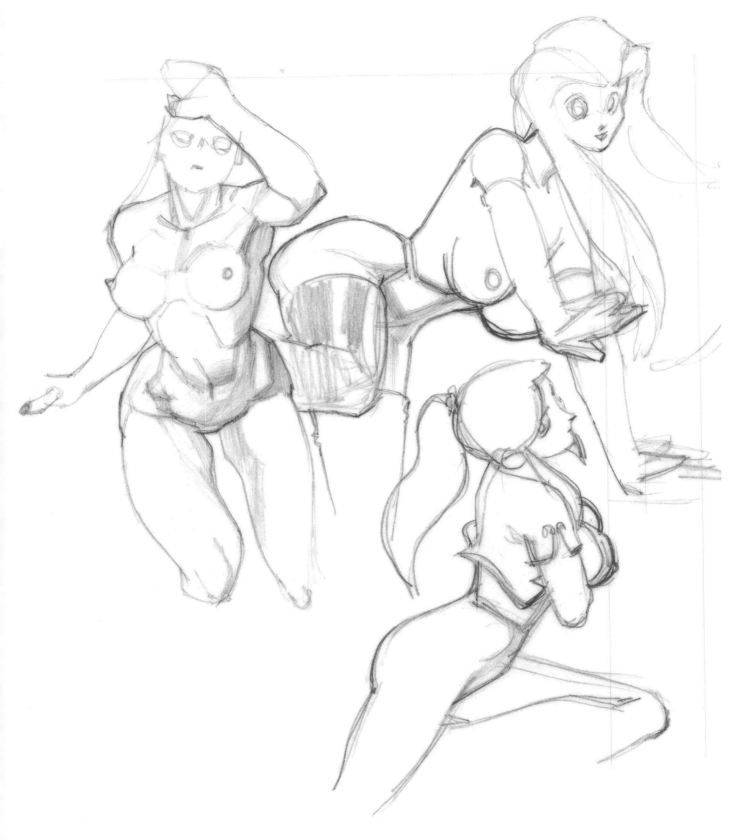

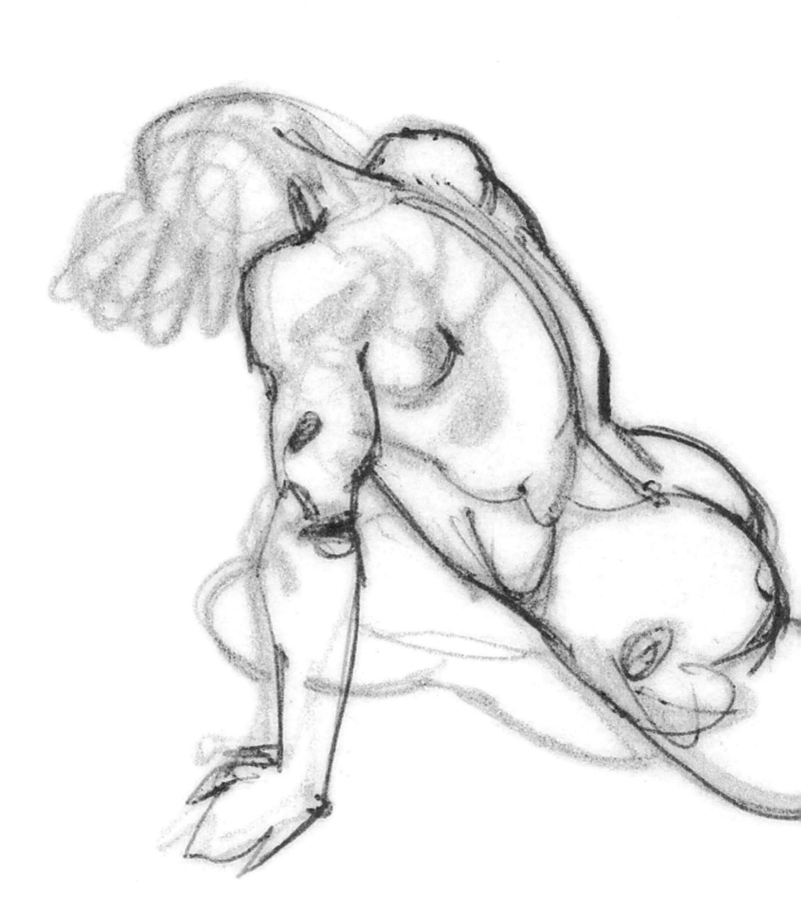

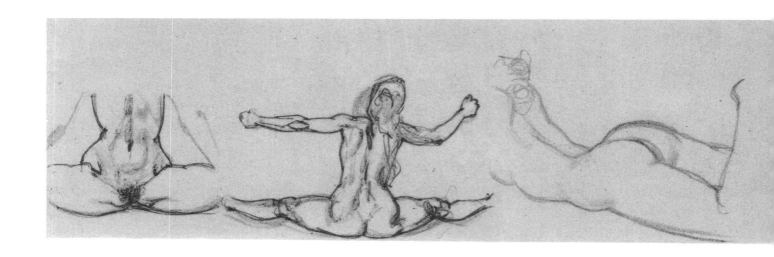

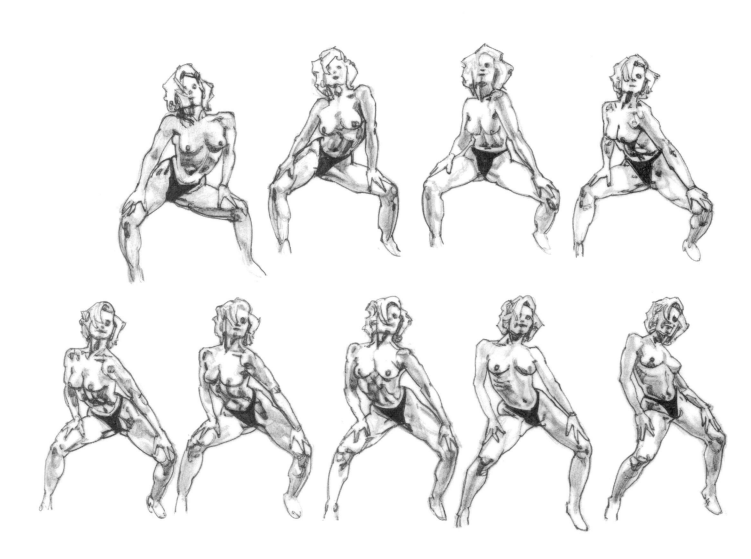

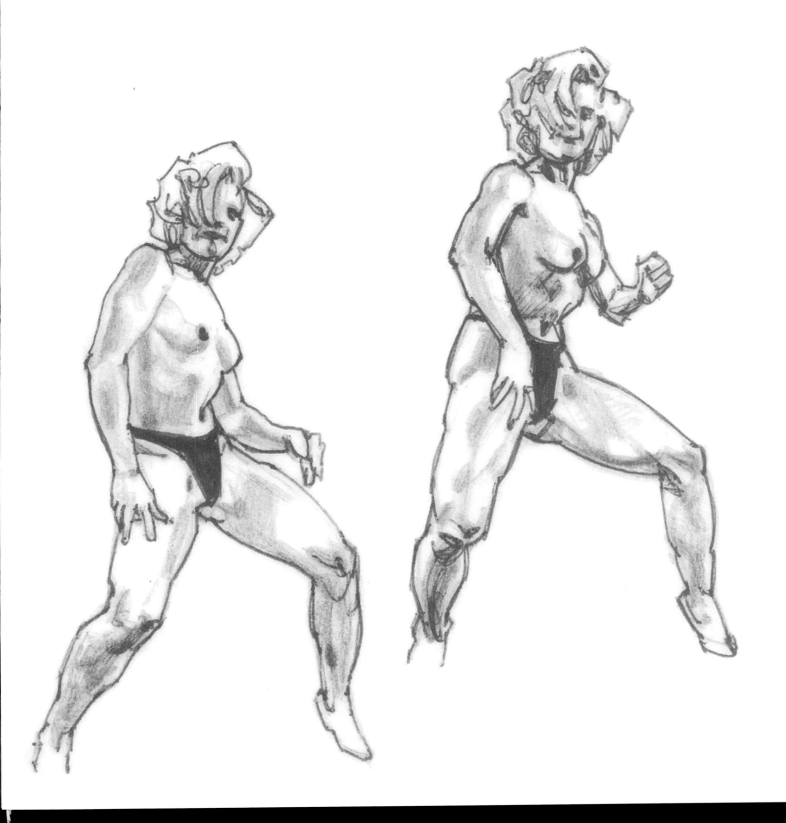

Flow

Forms of the human figure—in fact, all natural forms—flow into one another. Try to imagine your drawing as a contour map. Draw the contours of the body. Ignore the outline, which will appear as you draw the contours. To avoid messing up the placement of parts of the body, draw them in lightly: the head here, feet here, hands here, and so forth.

Then, go back and concentrate on the contour, the sweep of the arm, the solid structure of the knee. You're trying to sculpt the sketch, in the round, rather than putting random lines on a two-dimensional plane. Don't sketch it, caress it!

NEW THINGS - WHEN YOU'RE FINDING IT DIFFICULT TO FIND THE
RIGHT LINE, DO IT LIKE AN 'O' LEVEL - DO SOMETHING ELSE AND GO BACK TO IT.
ALSO, TRUST YOUR FEELINGS, LUKE: IF SOMETHING LOOKS WRONG, BUT THE REST
OF IT IS FINE, MAKE A MARK THAT LOOKS RIGHT, EVEN IF IT GOES AGAINST
YOUR TEXTBOOKS AND PRECONCEPTIONS ABOUT ANATOMY, LIGHTING ETC.
CHANCES ARE IF YOU THINK IT LOOKS WRONG, IT IS, AND YOUR BRAIN KNOWS BETTER
(AND YOUR EYES TOO).

DO EVERYTHING AS A SKETCH DEAD FAST

LIKE SINKIEWITZ, AND ADD FINISHES LATER - YOUR FINISHES DISTRACT YOU.

IT'S NOT ABOUT ONE PAINTING OR DRAWING. IT'S ABOUT HUNDREDS BUILDING UP IN STANDARD
ALSO - WHEN YOU FEEL YOU'RE ABOUT TO DRAW A CRAP LINE - DON'T DO IT!
LOOK FOR FLOW BUT ALSO LOOK FOR THE QUICK EXIT!

DON'T SPEND HOURS PUTTING PAINT ON THINGS - IF IT WORKS
WITH A DAB OF WATERCOLOUR, IT'LL DO!

ALL OF IT IS DOWN TO THE FLOW OF FORMS.
FIT ANATOMY TO DEAL WITH THIS. FEEL THE FLOW!

THE GRAND, BASIC OVERALL FLOW OF THE FORMS -
FOOT POSITION, ANGLE OF HIP & SHOULDERS, SWING

CONFIDENCE, TOUCH OF GENIUS, PERFECTION, ACE OF CAPS, THE GOD OF ART
FLOW, LOVE OF CREATION
DO AS MUCH AS YOU CAN, IN WATERCOLOUR BEFORE IMPASTO.
PUT FLOW INTO YOUR MADE UP DRAWINGS TOO -
LOOK FOR POSSIBILITIES.

"YOU SHOULD NOT EVEN THINK OF ERRORS AT ALL IN CONNECTION
WITH DRAWING; EVERY MARK MADE IS A PROGRESS TOWARDS
THE FINAL STATEMENT. IF YOU MAKE A MARK, SAY A LINE
DENOTING WHAT SEEMS TO BE THE MAIN DIRECTION OF SWING
IN ONE OF THOSE POSES FOR EXAMPLE, AND HAVING DECIDED
IT IS NOT QUITE RIGHT, RUB IT OUT, THEN YOU COULD QUITE
EASILY PUT IT BACK IN THE SAME PLACE AGAIN. BETTER TO
LEAVE IT, AND DRAW YOUR LATER ESTIMATE ALONGSIDE IT.
IF THAT ONE SEEMS RIGHT, OR NEARER RIGHT, AS THE DRAWING
PROGRESSES, REINFORCE IT. THE EARLIER LINES WILL
DIMINISH BY COMPARISON, NOT AFFECTING THE FINAL
STATEMENT, AND YET BY THEIR PRESENCE SHOWING-HOW
YOUR THINKING PROGRESSED." (JOHN RAYNES ON LIFE DRAWING)

SCRUFFY
SHOULDER
STRAP

SOPHIA
10-42

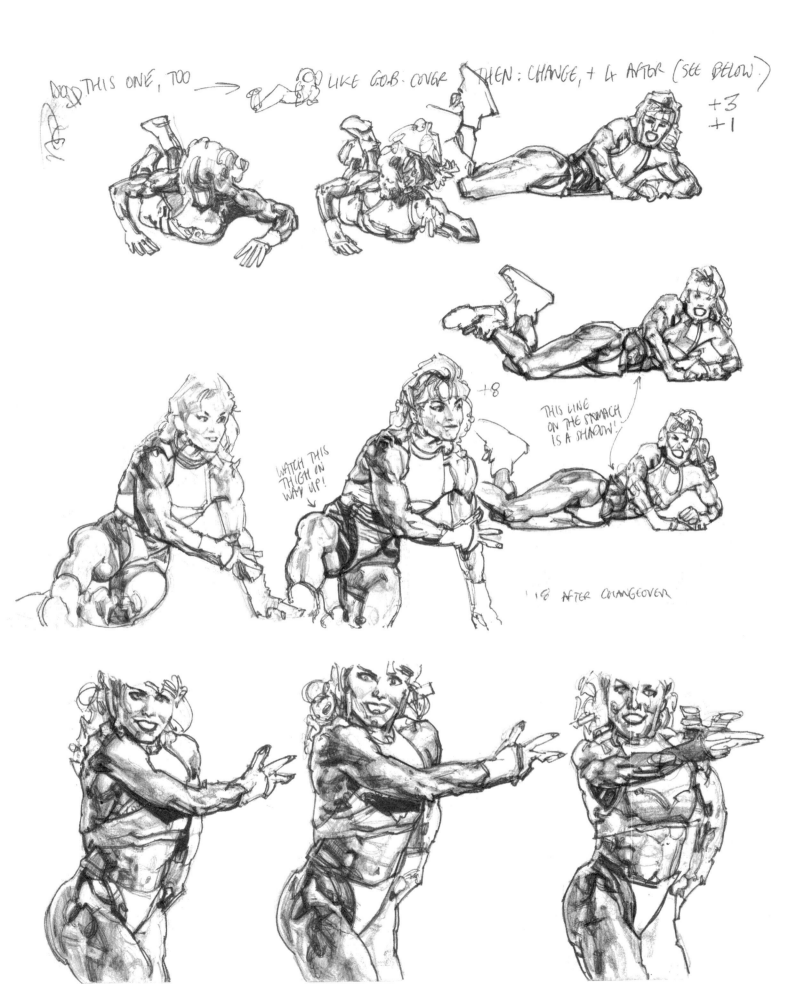

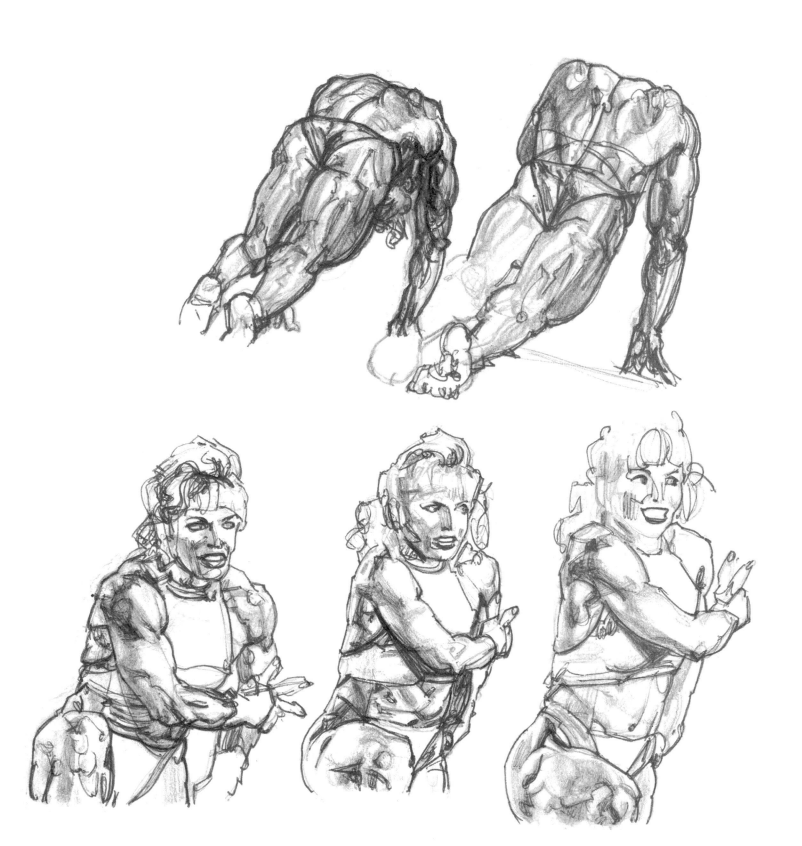

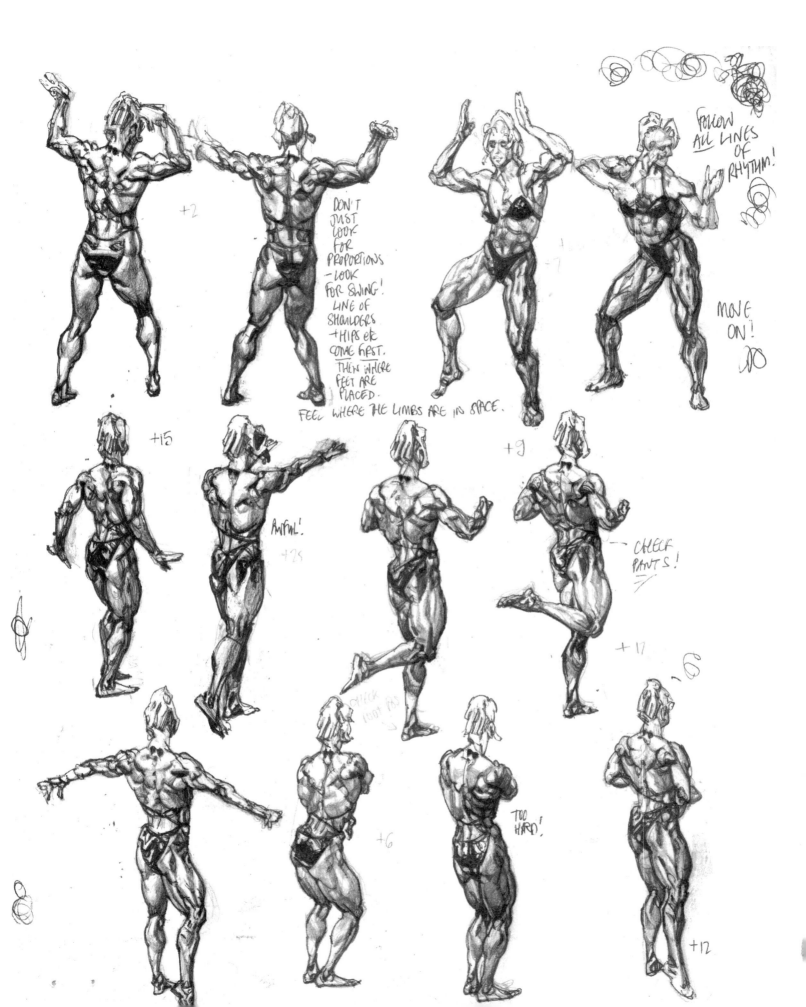

DON'T JUST LOOK FOR PROPORTIONS - LOOK FOR SWING! LINE OF SHOULDERS + HIPS etc COME FIRST. THEN WHERE FEET ARE PLACED.

FEEL WHERE THE LIMBS ARE IN SPACE.

+2

FOLLOW ALL LINES OF RHYTHM!

MOVE ON! DO

+15

AWFUL!

+25

+9

CHEEK PANTS!

+17

QUICK FOOT POS

+6

TOO HARD!

+12

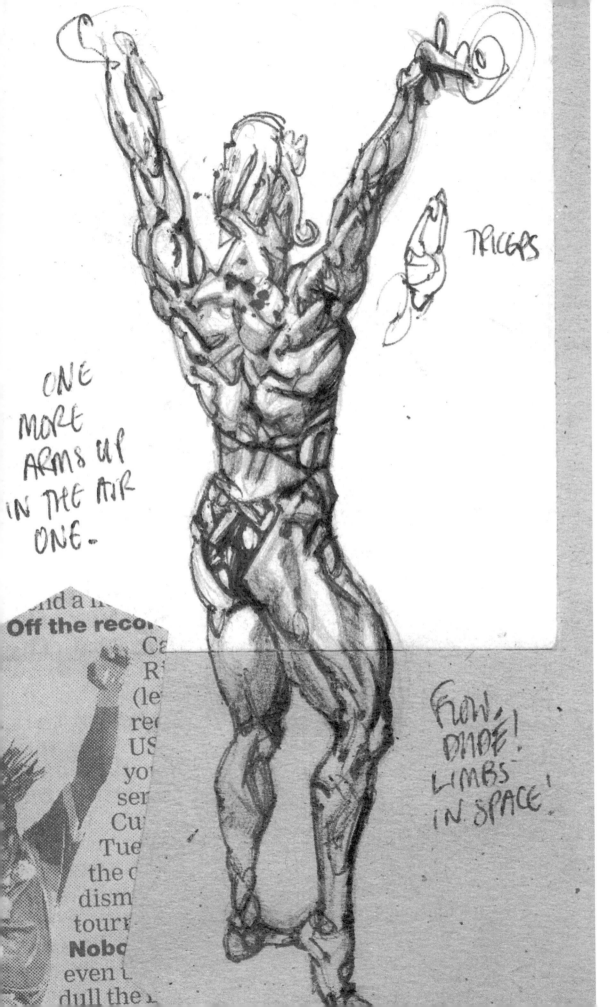

TRICEPS

ONE MORE ARMS UP IN THE AIR ONE.

FLOW DUDE! LIMBS IN SPACE!

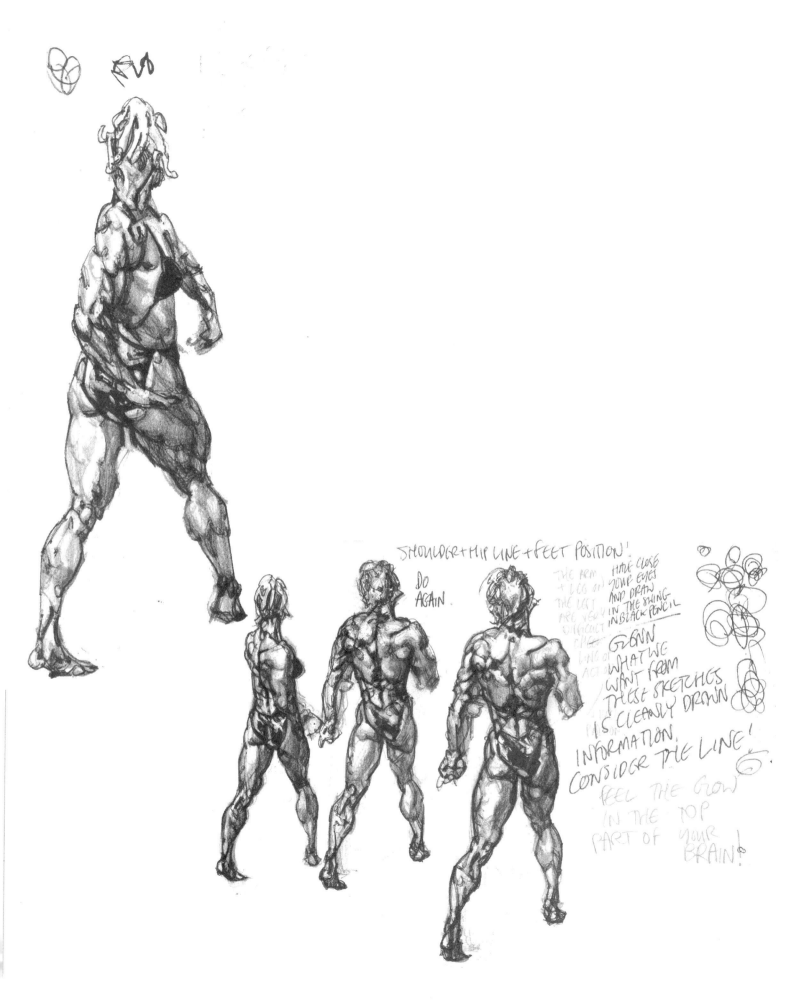

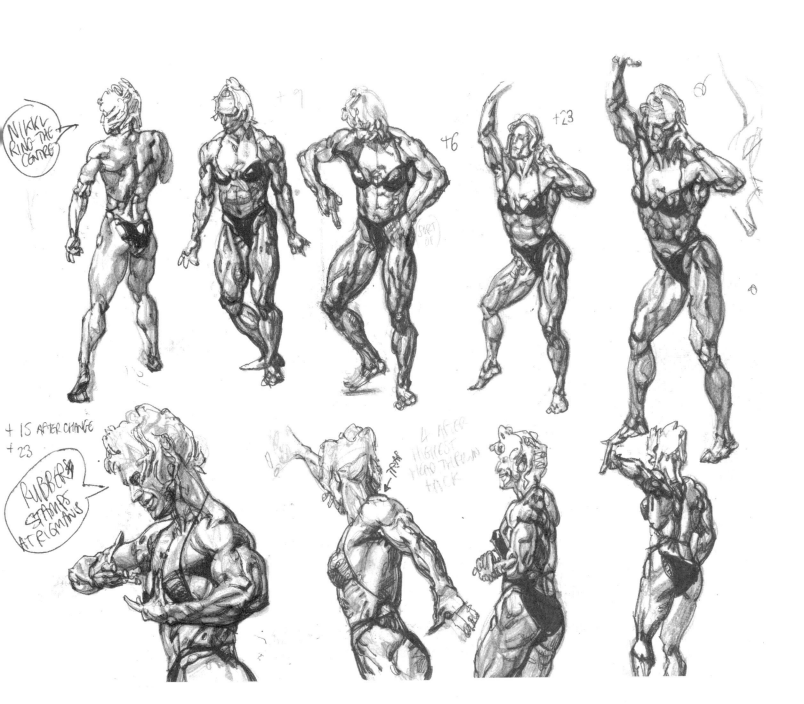

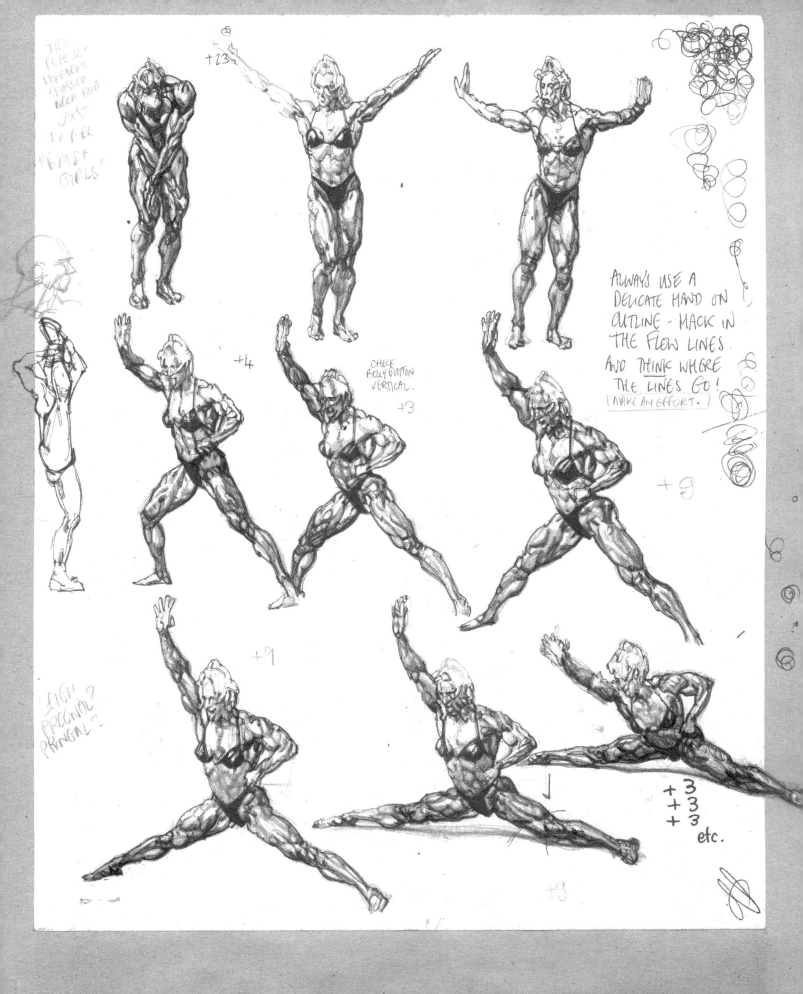

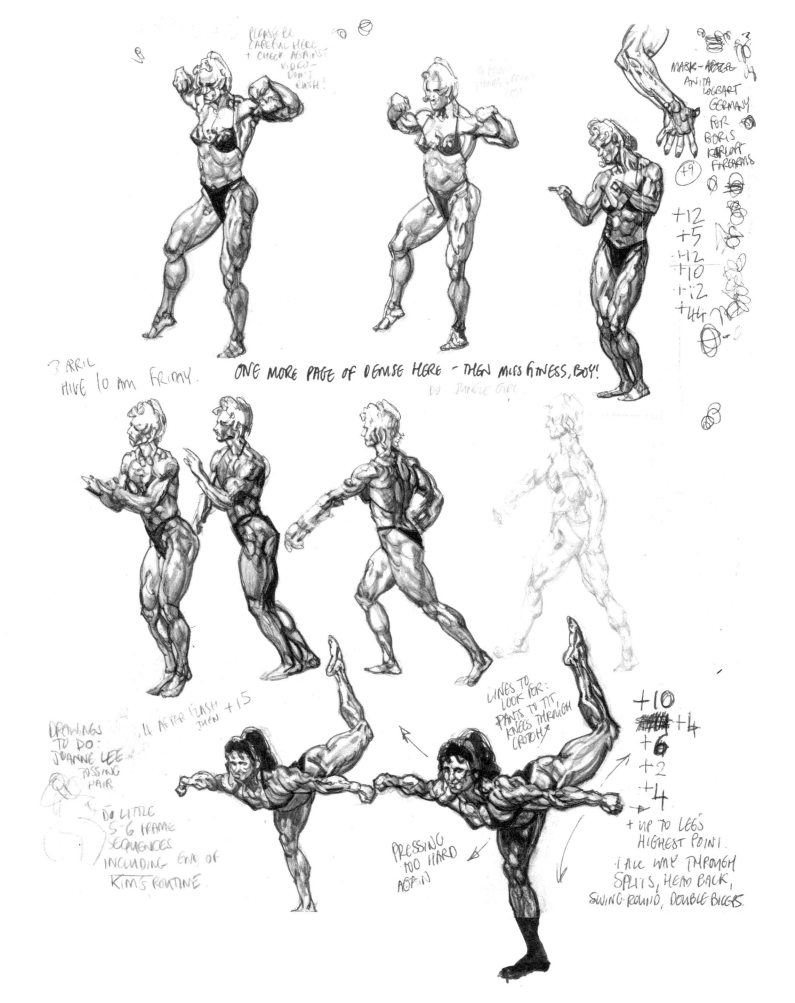

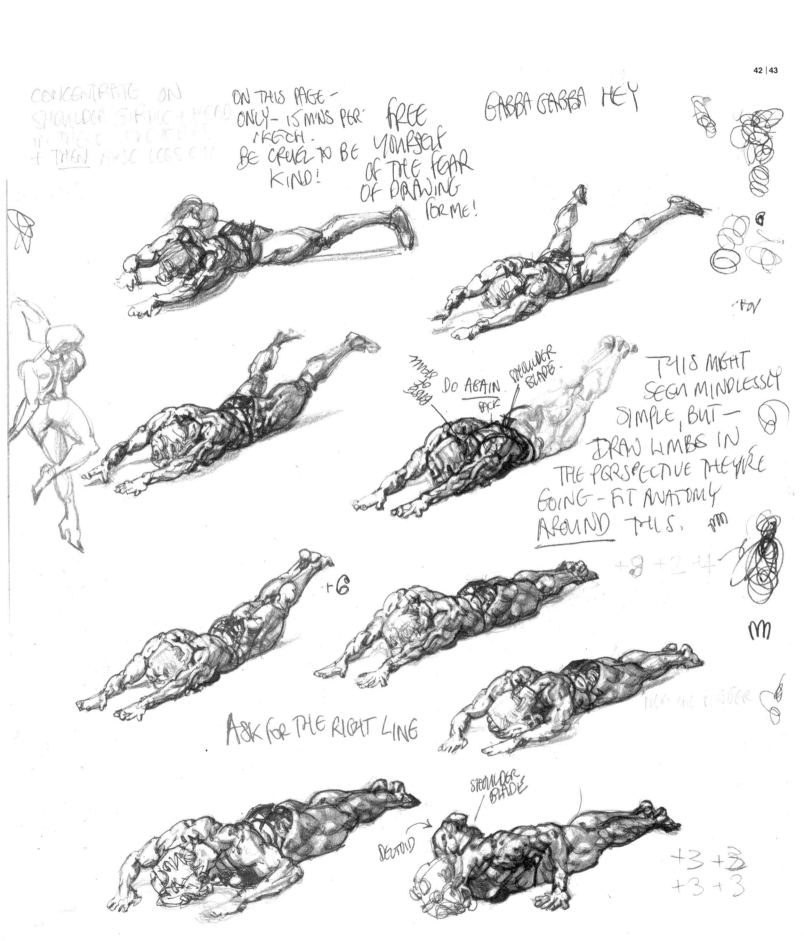

CONCENTRATE ON
SHOULDER STRUCT + HEAD
IN THESE EXERCISES
+ THEN ARSE LEGS ETC

ON THIS PAGE -
ONLY - 15 MINS PER
SKETCH.
BE CRUEL TO BE
KIND!

FREE
YOURSELF
OF THE FEAR
OF DRAWING
FORME!

GABBA GABBA HEY

DO AGAIN

MUSELS TO ELBOW

SHOULDER BLADE

BACK

THIS MIGHT
SEEM MINDLESSLY
SIMPLE, BUT -
DRAW LIMBS IN
THE PERSPECTIVE THEY'RE
GOING - FIT ANATOMY
AROUND THIS.

+6

+8 +2 +4

ASK FOR THE RIGHT LINE

NICK THE RUBBER

SHOULDER
BLADE

DELTOID

+3 +3
+3 +3

I JUST WANT TO SAY NOT IN THESE SKETCHES, BUT IN YOUR PAYING ARTWORK — DRAW LIKE JACK KIRBY AND FIT THE ANATOMY IN!

GLENN—WHAT I WANT YOU TO DO NOW, ON YOUR COMICS WORK (NOT ON THESE SKETCHES) IS TO DRAW WITHOUT REFERENCE, IN CARTOON AS MUCH AS POSSIBLE: USE WHAT YOU'VE LEARNED!

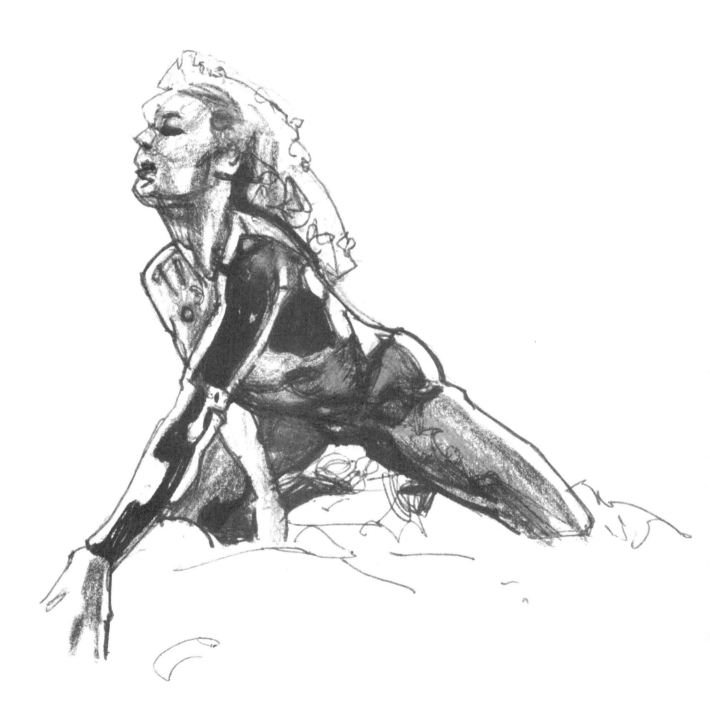

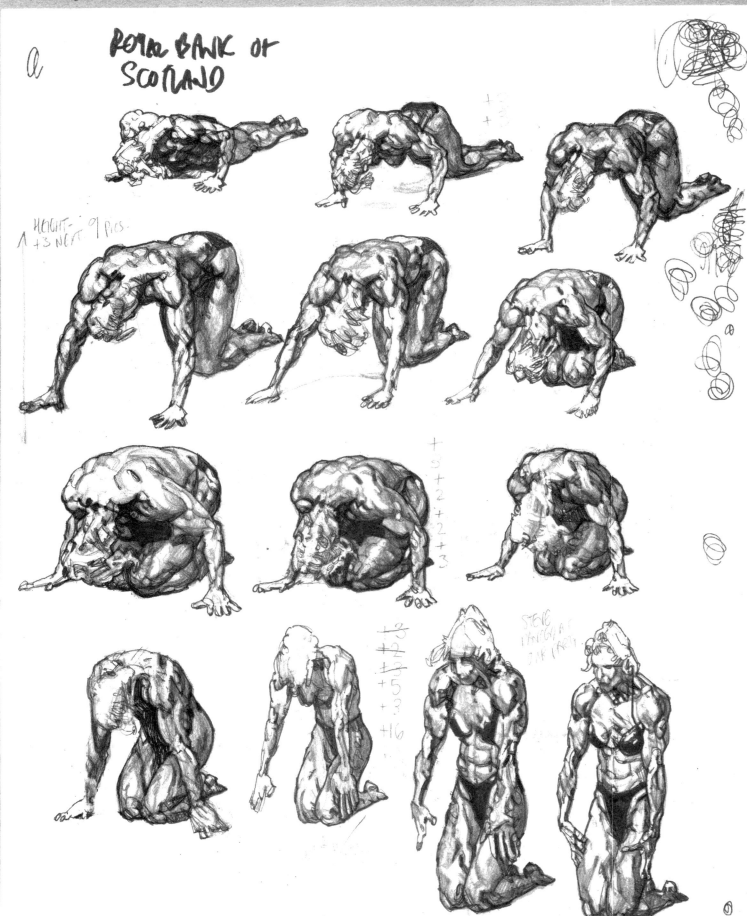

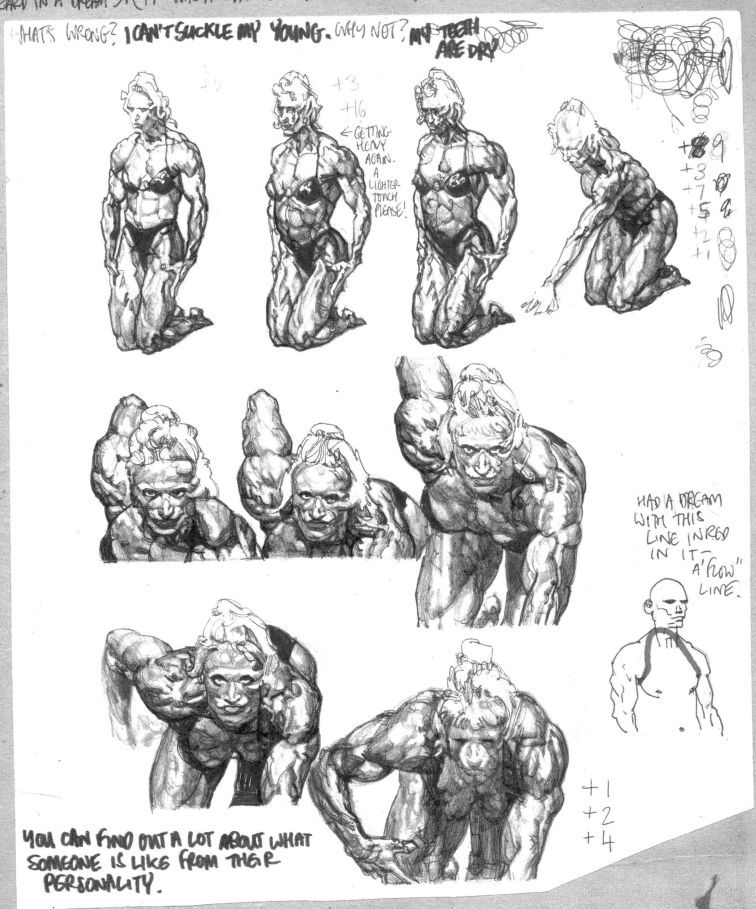

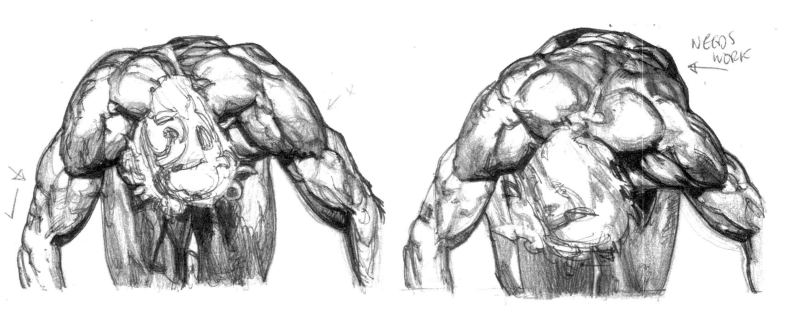

NEGOS
WORK

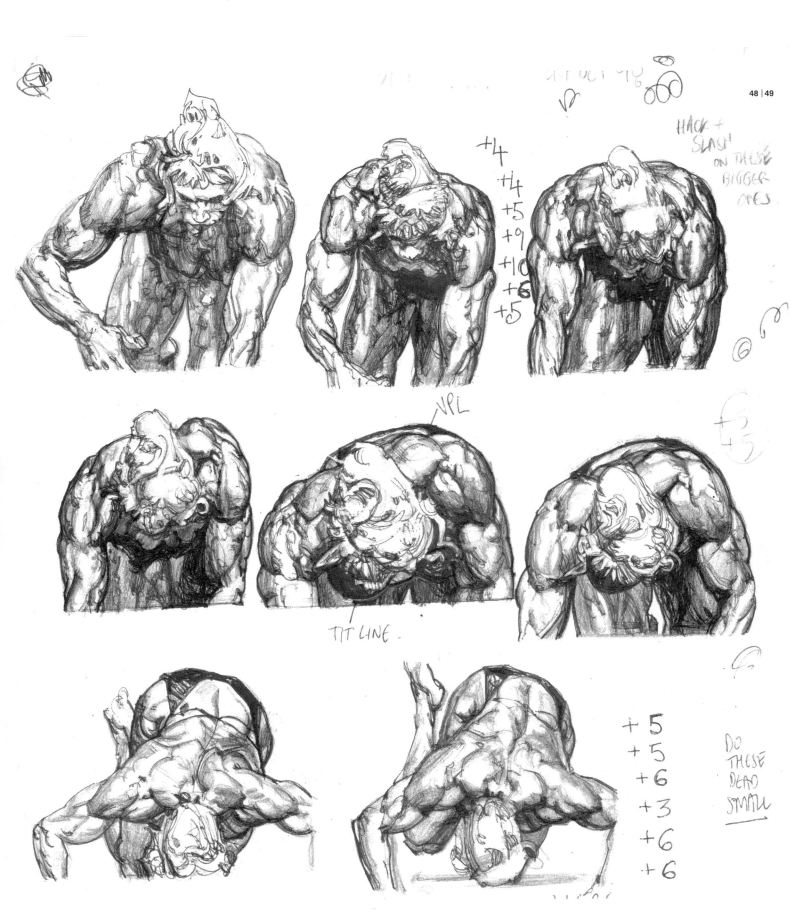

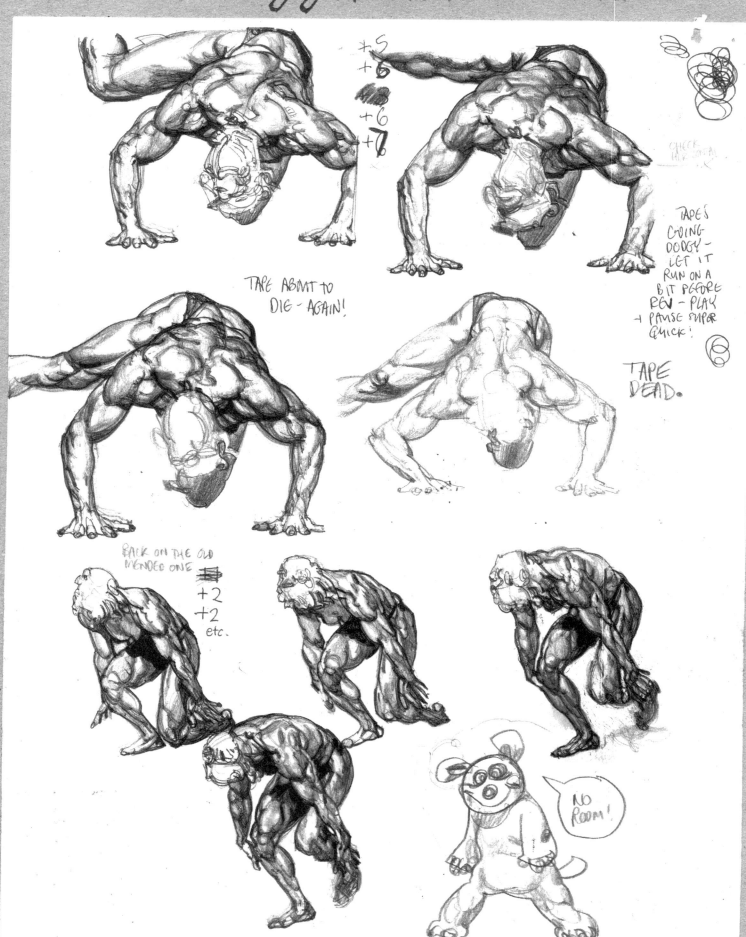

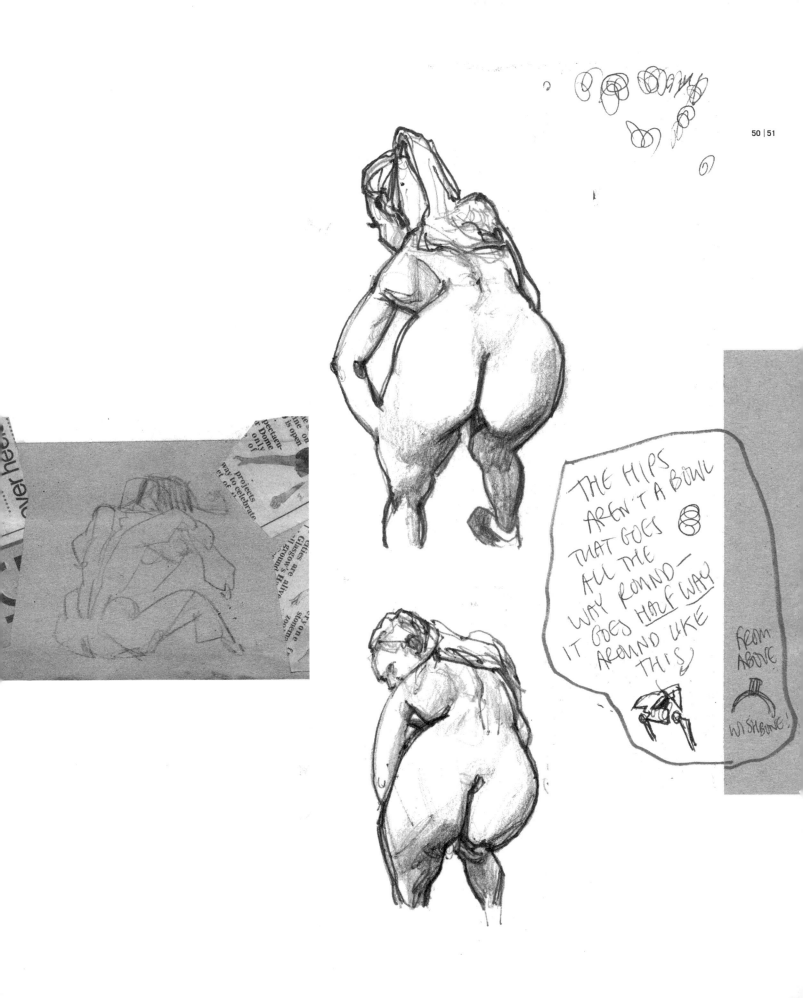

THE HIPS
AREN'T A BOWL
THAT GOES
ALL THE
WAY ROUND—
IT GOES HALF WAY
AROUND LIKE
THIS

FROM
ABOVE

WISHBONE!

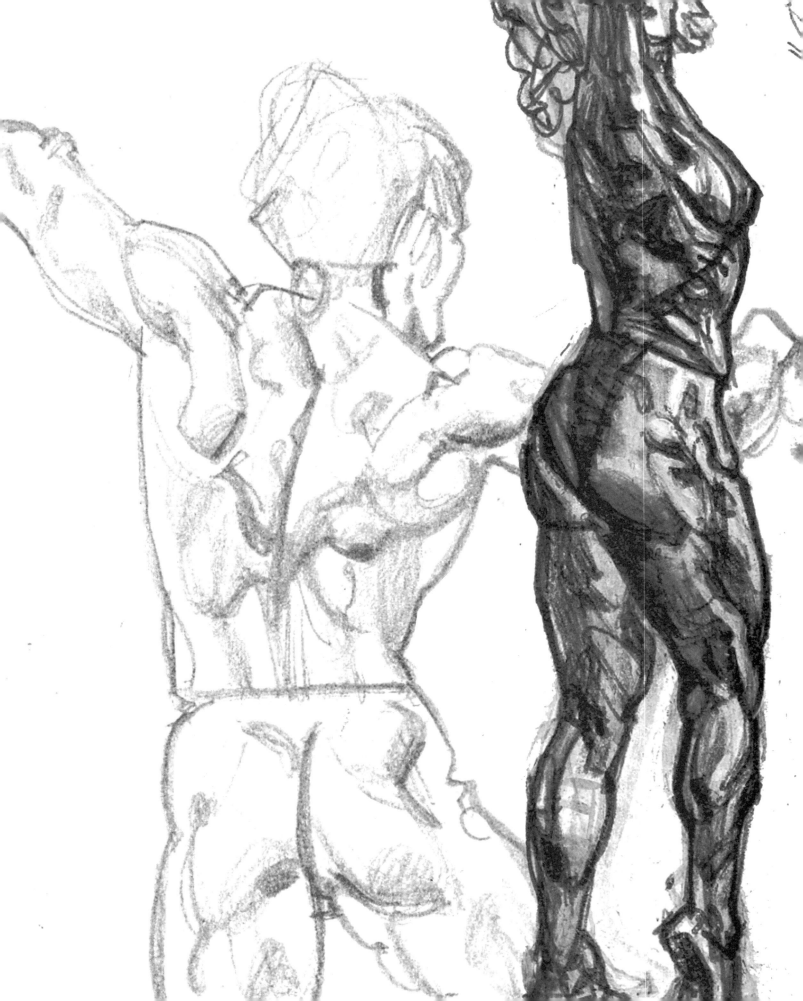

CLOSE
TO CHANGE

(81) 2
OR 3
MORE

+1
+2
+3
+2
+3

KEVIN
LEVRONE
MR. O TAPE

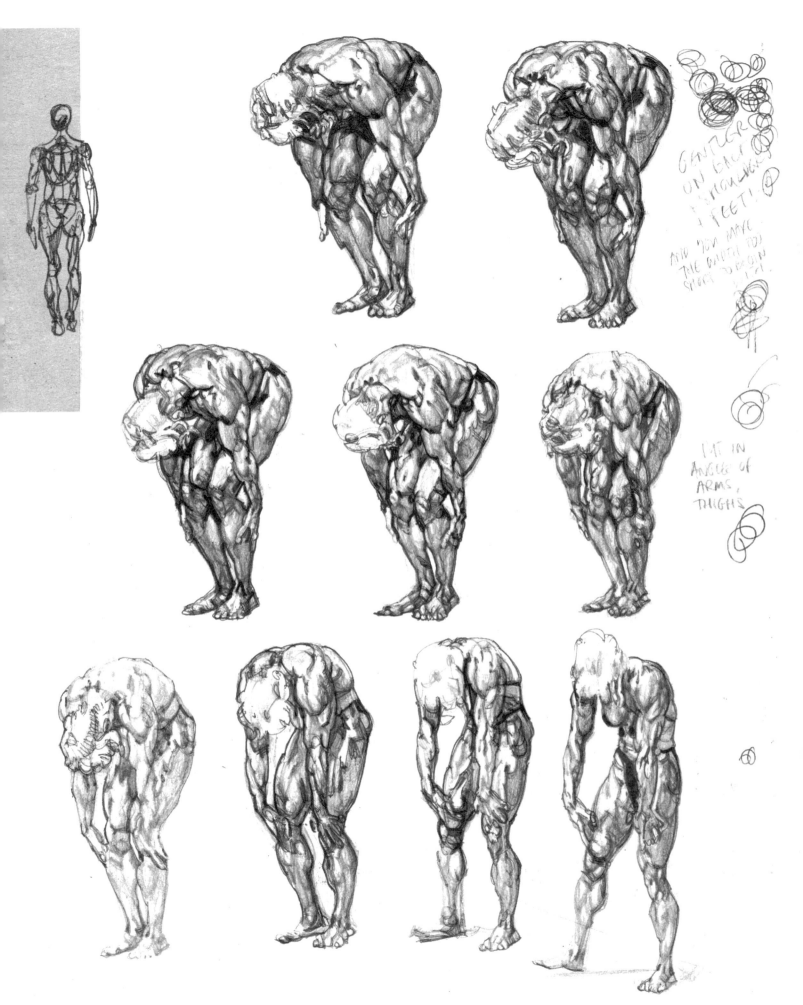

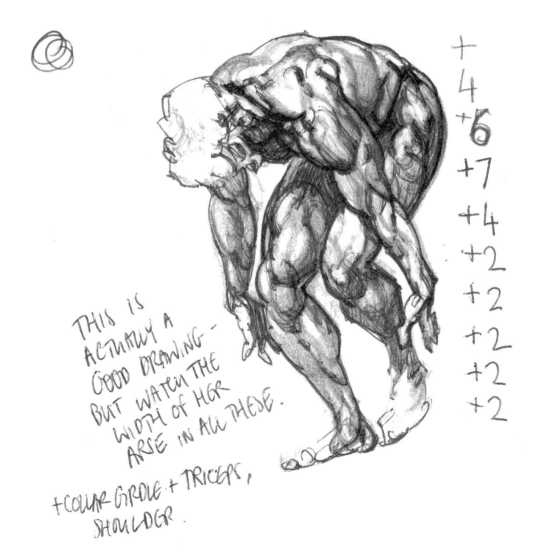

THIS IS
ACTUALLY A
GOOD DRAWING—
BUT WATCH THE
WIDTH OF HER
ARSE IN ALL THESE.

+COLAR GIRDLE + TRICEPS,
SHOULDER.

+
4
+6
+7
+4
+2
+2
+2
+2
+2

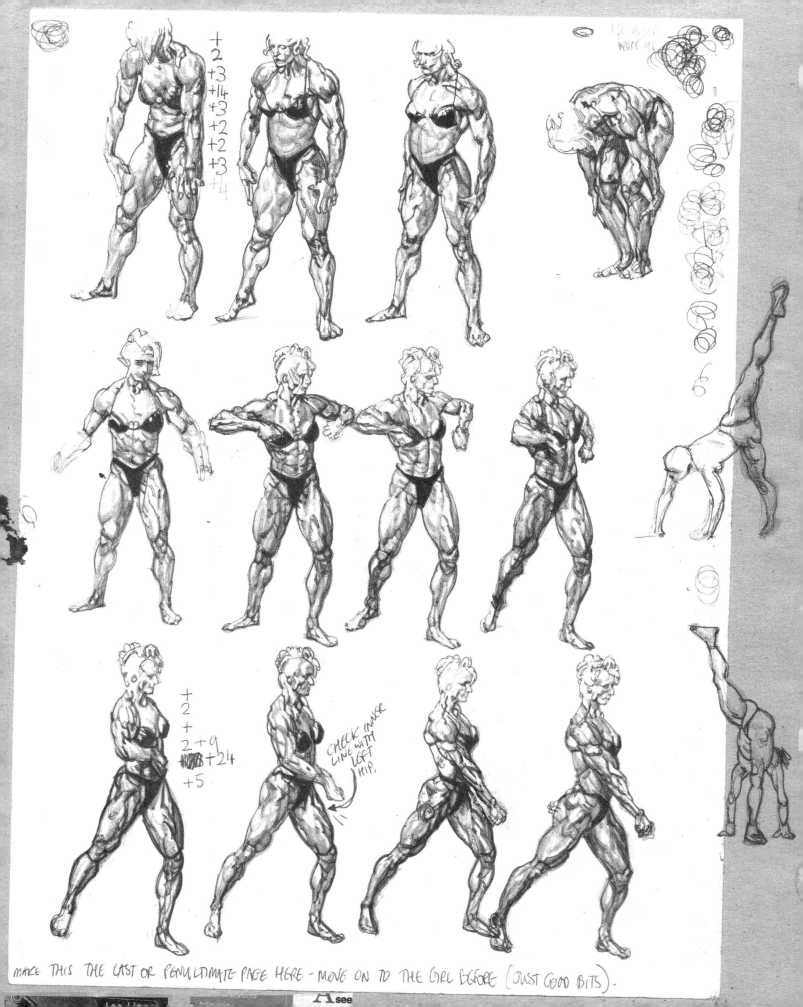

+2
+3
+14
+3
+2
+2
+3
+4

+2
+ 2 +9
+ +24
+5

CHECK INNER
LINE WITH
LEFT
HIP.

MAKE THIS THE LAST OR PENULTIMATE PAGE HERE - MOVE ON TO THE GIRL BEFORE (JUST GOOD BITS).

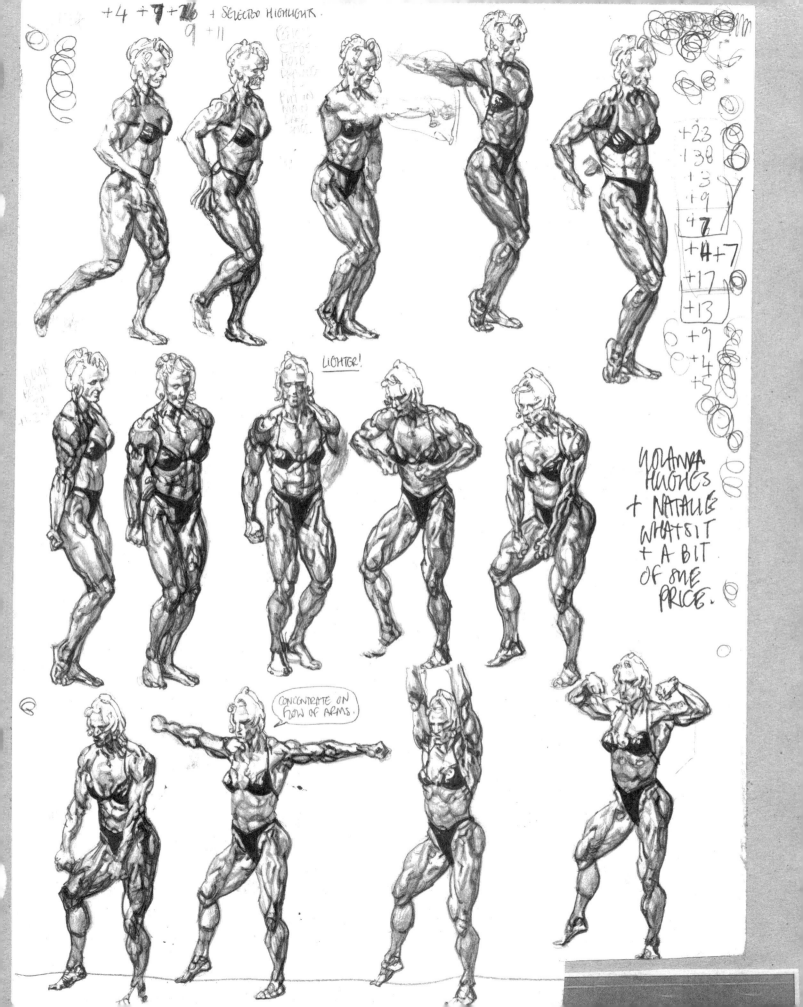

Reverse Flow

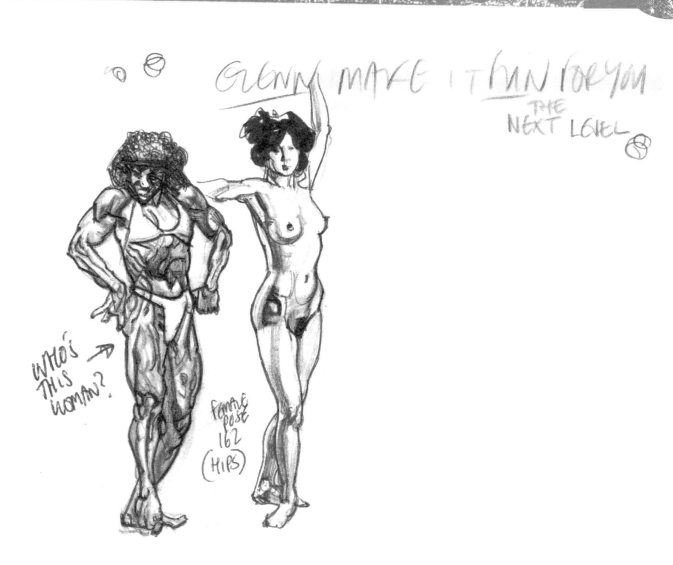

As you attempt to "sculpt" your drawing, be aware of the positions of the parts of the body that you can't see. If you're looking at someone in profile from the right, you may not be able to see his left shoulder from where you're standing. Nevertheless, you need to be aware of its position and how it ties in with the parts of the body you can see. You need to know how the body's contours will be affected by the position of these hidden elements. By keeping conscious of where all the body parts—visible or not—are located in your drawing, you can reinforce the conviction of your line.

DO YOU WANT TO SPEAK TO MY BETTER HALF? HOLD ON, I'LL PUT THE PHONE ON MY OTHER EAR.

A JOKE
I MADE
UP 24th
JAN 01

+4
+4
+3
+2

HOLD UP YOUR DRAWING IN FRONT
OF SUBJECT. AND LET

+3
+3
+28
+15

THIS BUMP IS NOT THE SPINE!

3 white dots...
2ND WHITE
DOT APPEARS.
1st ONE IS
DEVILS NOSE!

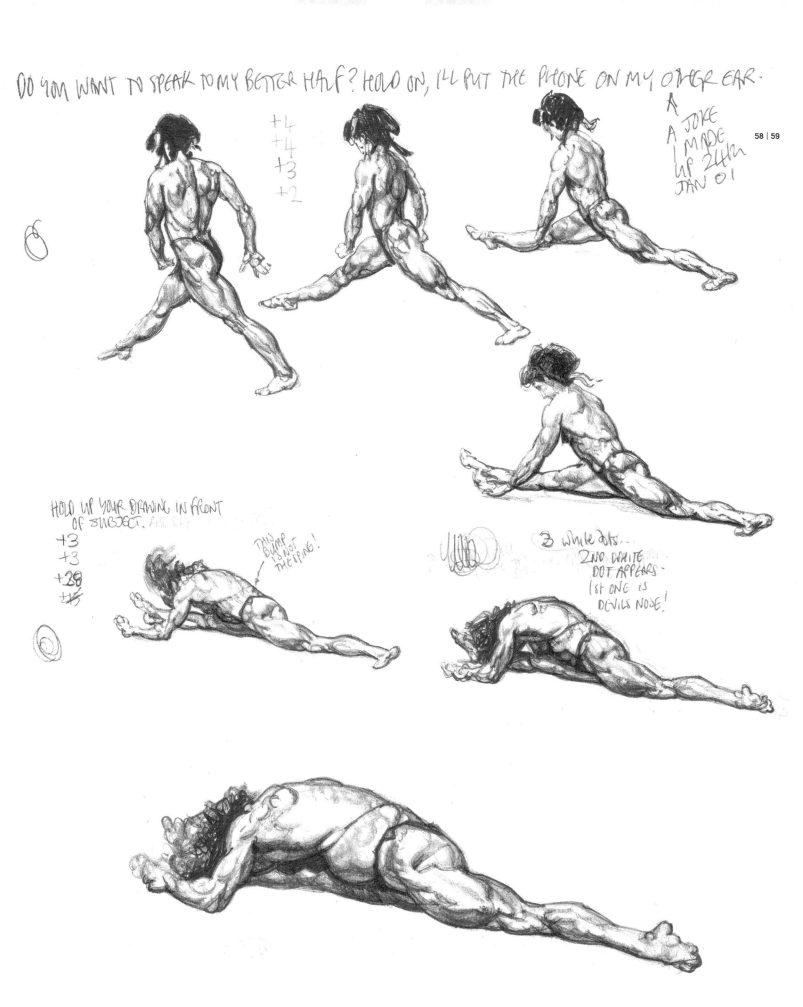

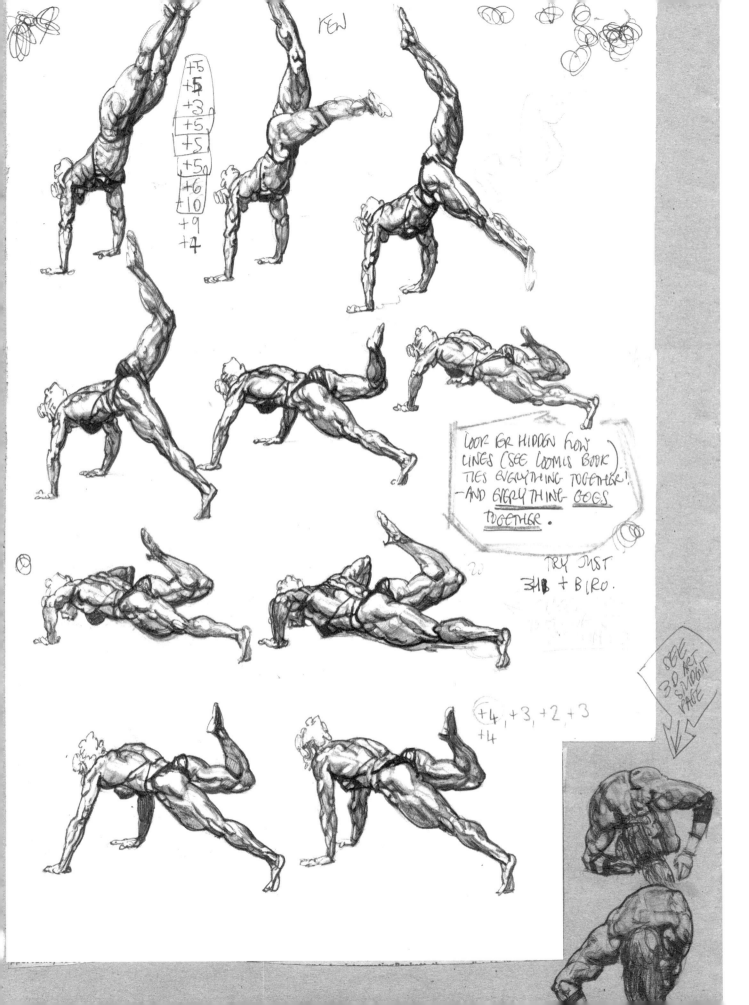

KEN

+5
+5
+3
+5
+5
+5
+6
+10
+9
+4

LOOK FOR HIDDEN FLOW LINES (SEE LOOMIS BOOK) TIES EVERYTHING TOGETHER! —AND EVERYTHING GOES TOGETHER.

TRY JUST 3HB + BIRO.

+4, +3, +2, +3
+4

SEE 3-D ART STUDENT PAGE

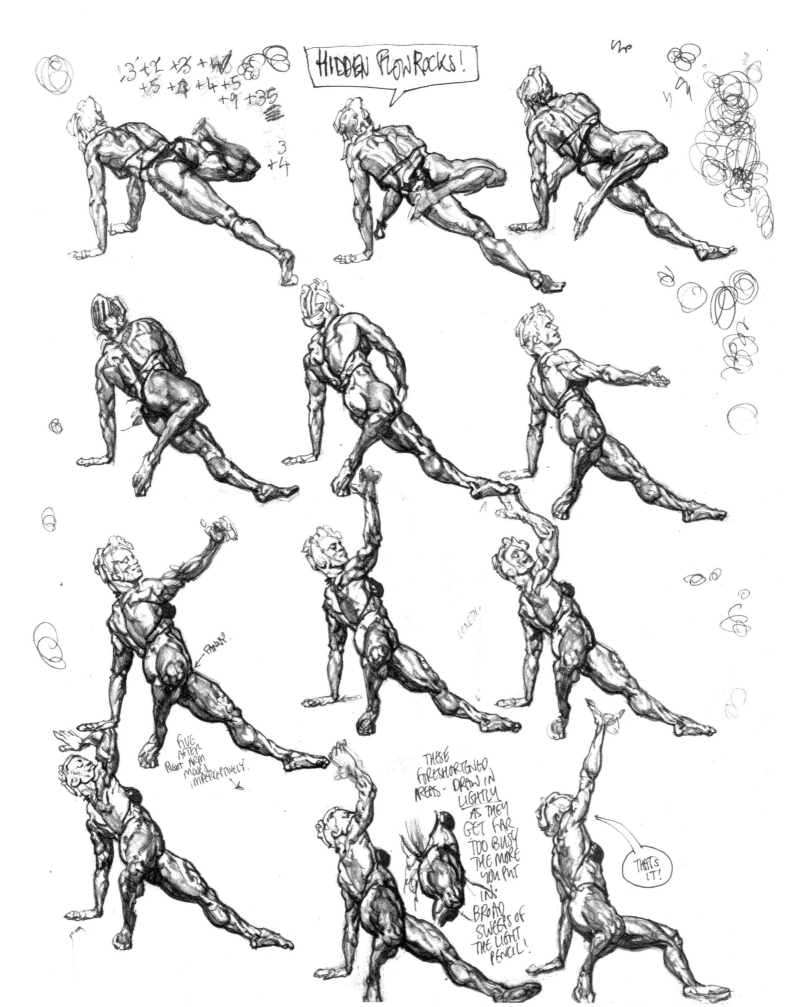

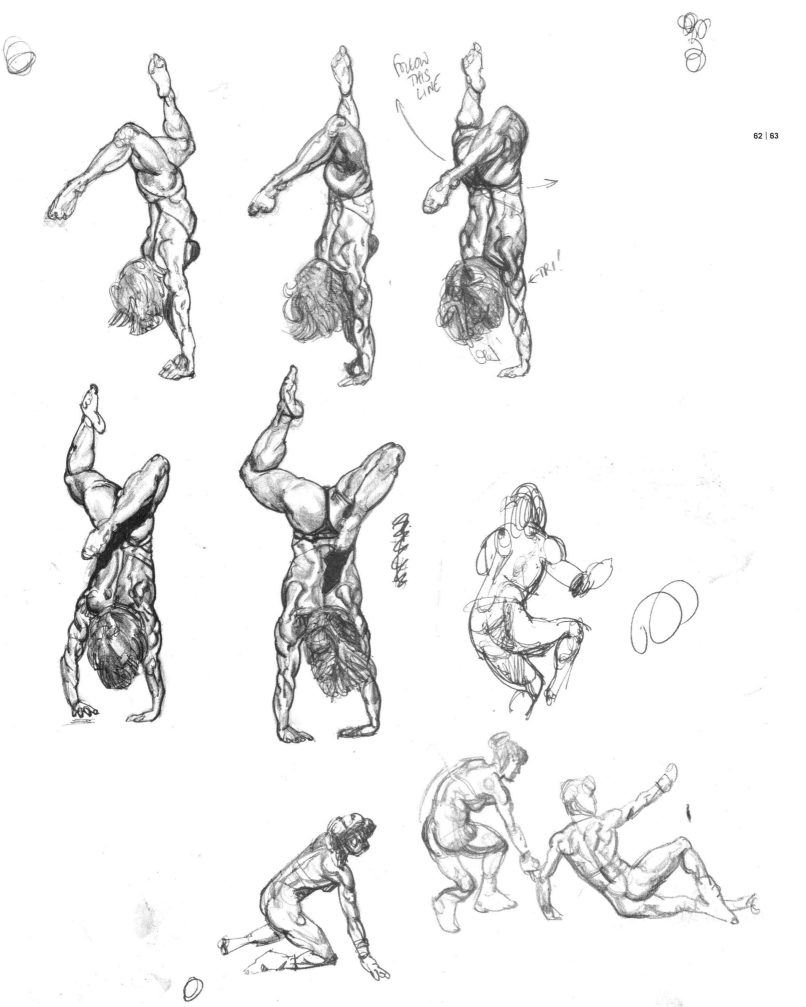

FOLLOW THIS LINE

←TRI!

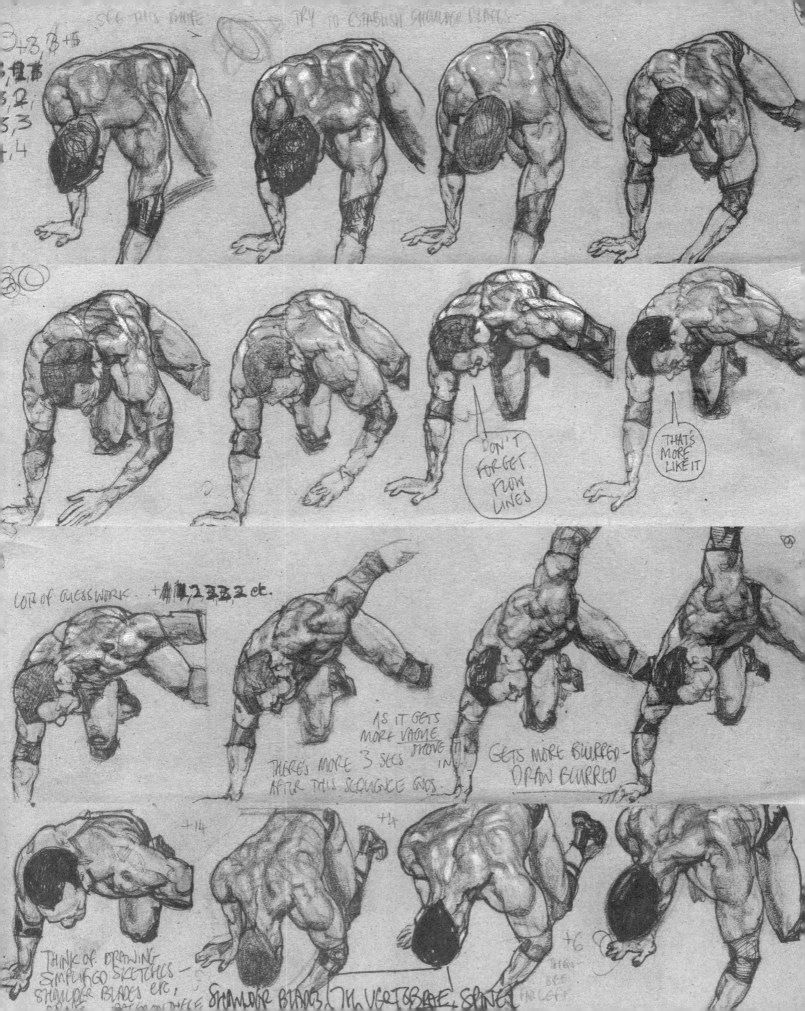

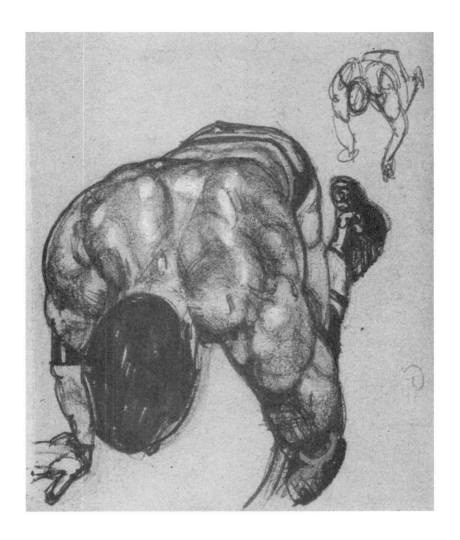

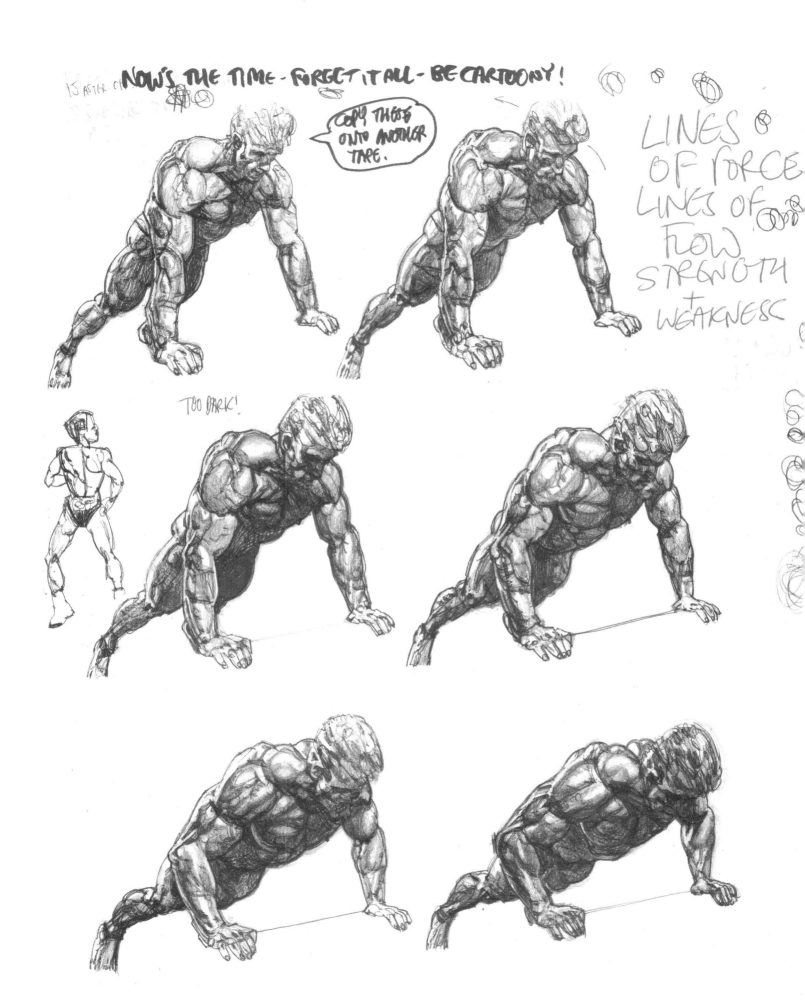

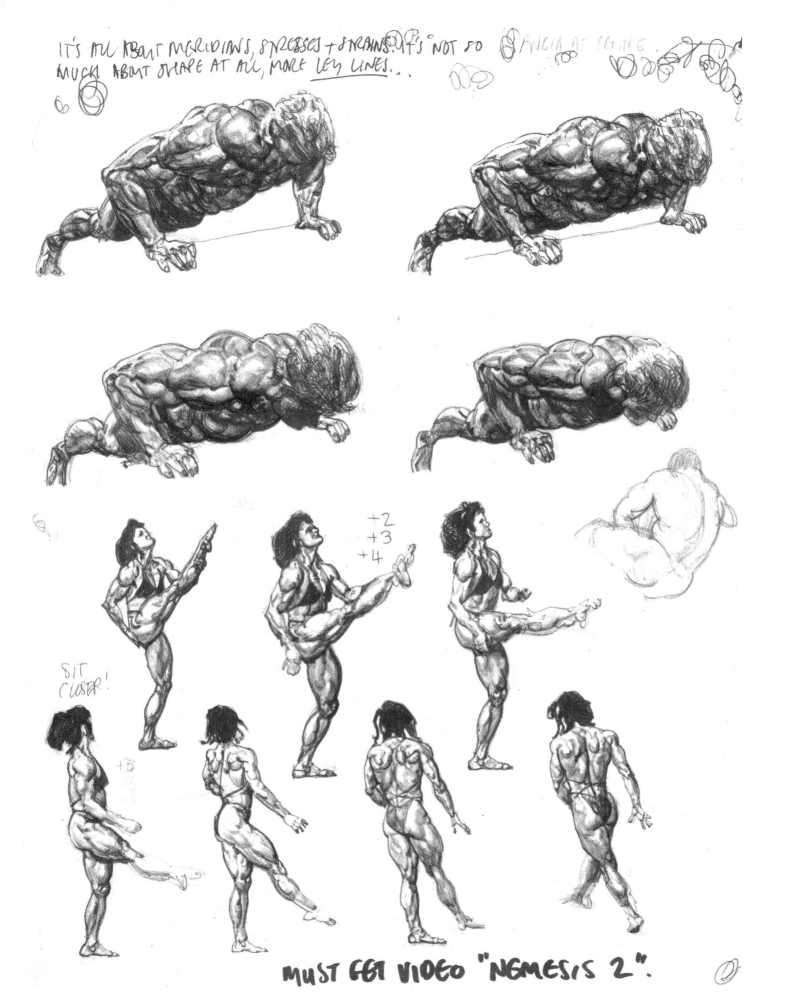

IT'S ALL ABOUT MERIDIANS, STRESSES + STRAINS. IT'S NOT SO
MUCH ABOUT SHAPE AT ALL, MORE LEY LINES...

+2
+3
+4

SIT
CLOSER!

MUST GET VIDEO "NEMESIS 2".

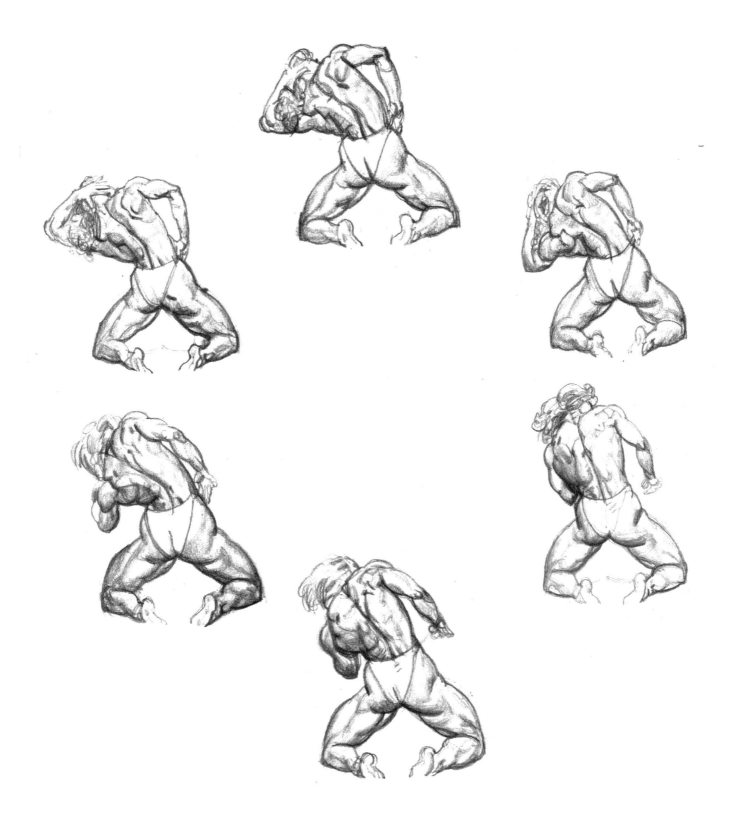

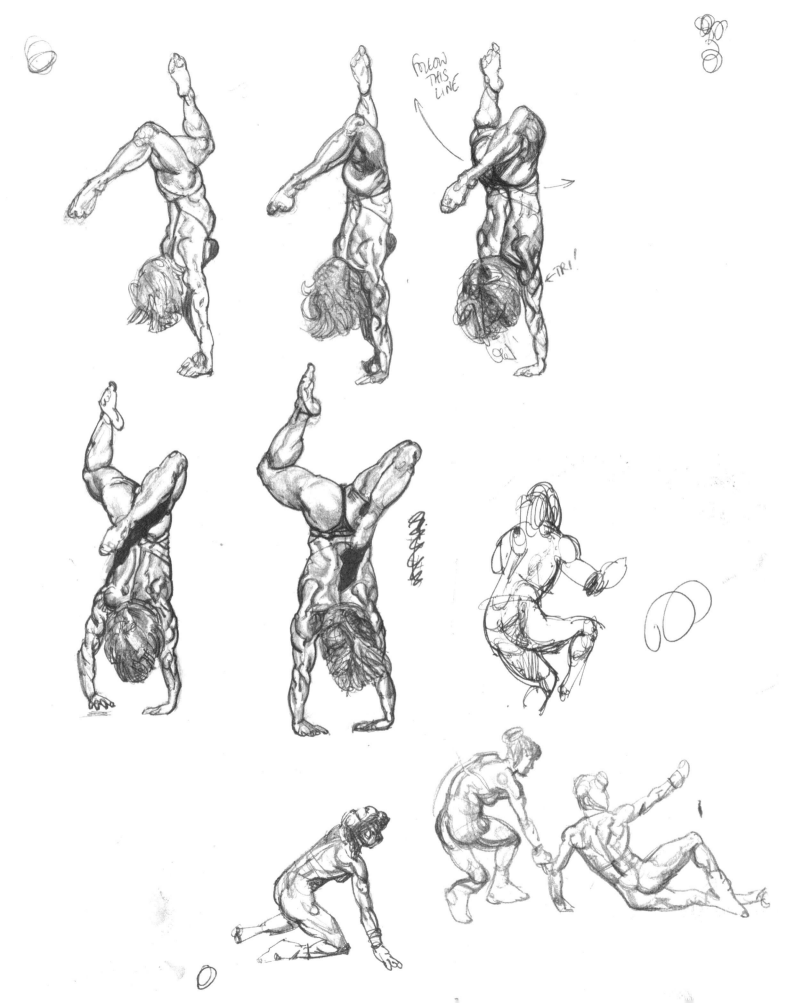

FOLLOW THIS LINE

←TRI!

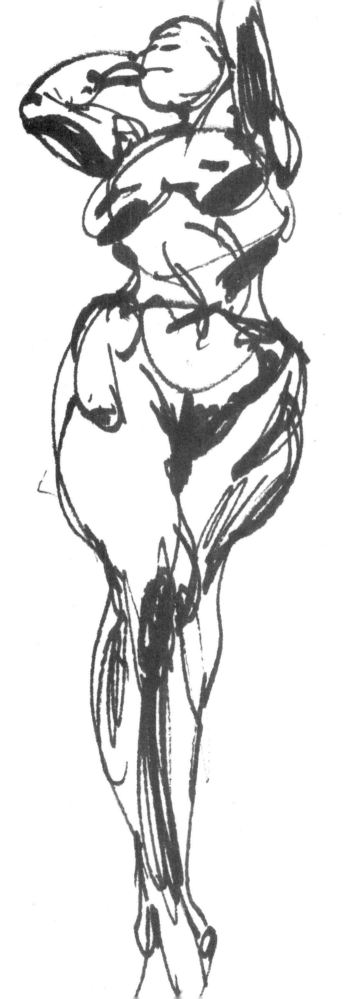

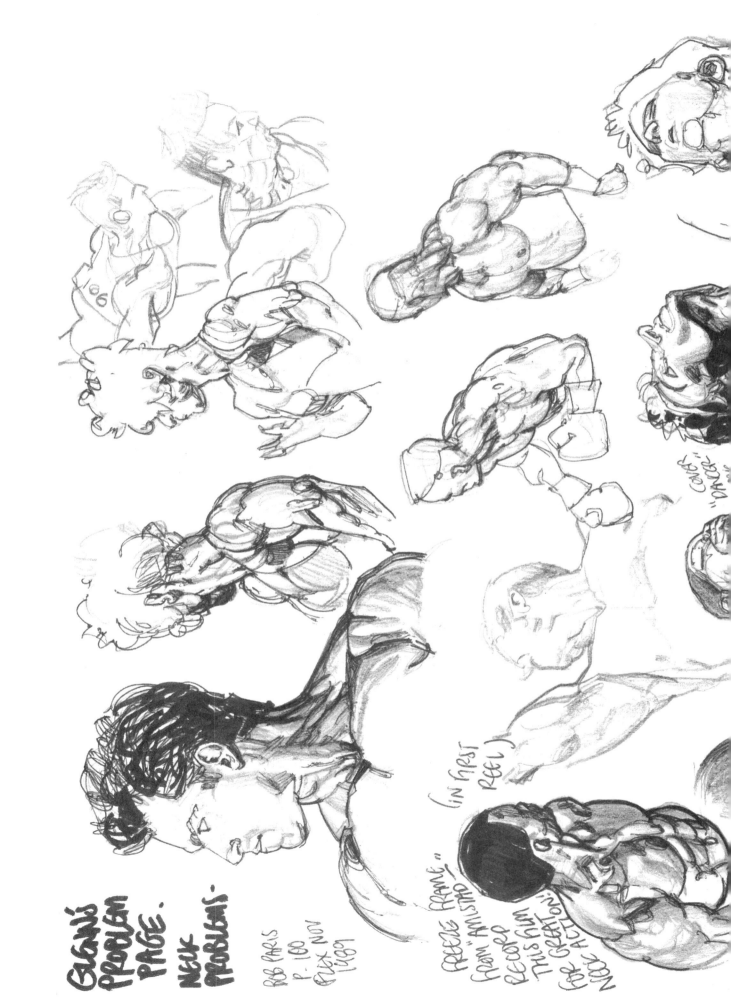

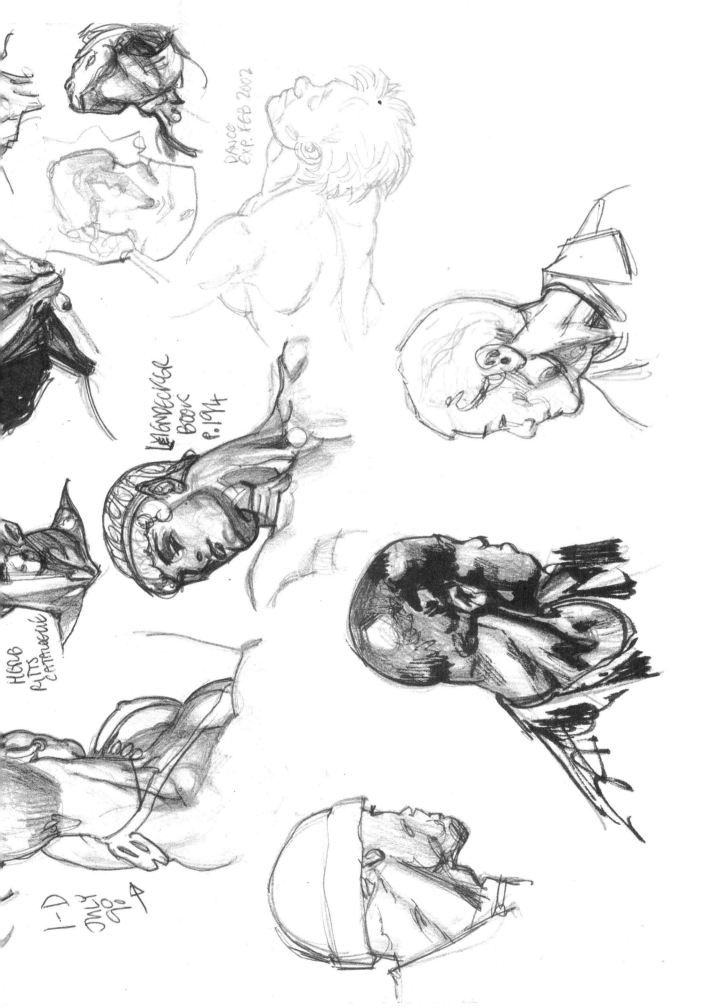

DANCE
EXP FEB 2002

LEONARDOR
BOOK
P.194

HEAD
PITTS
CATHEDRAL

I-D
ONLY

How to Convey Movement

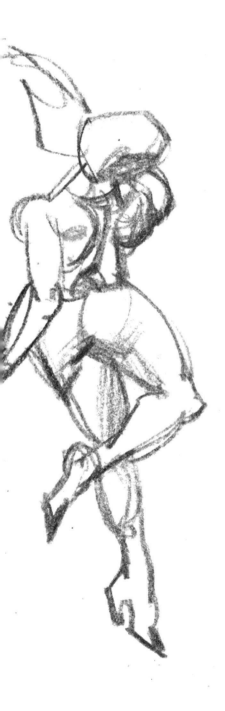

If you draw something quickly, you add an urgency to your picture that helps to convey energy and motion, which may be lacking in more labored pieces. If you spend too long on a drawing, it can become stodgy and inert. The trick is to sketch rapidly and then go back to refine the details.

Try to capture and hold a mental picture of whatever quality you wish to convey in the drawing. It may be a feeling of movement or weight, or of steeliness, or of sensuality. This feeling can filter through your hands and imprint itself in some mysterious way on the finished work.

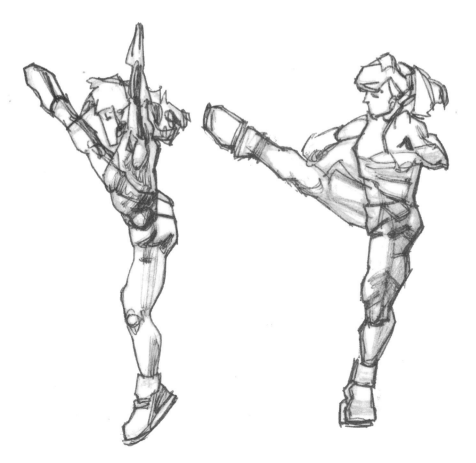

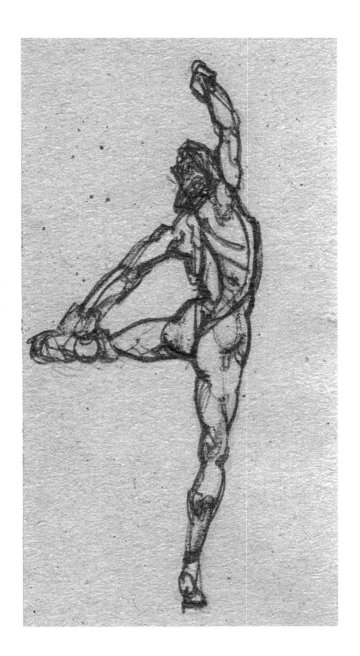

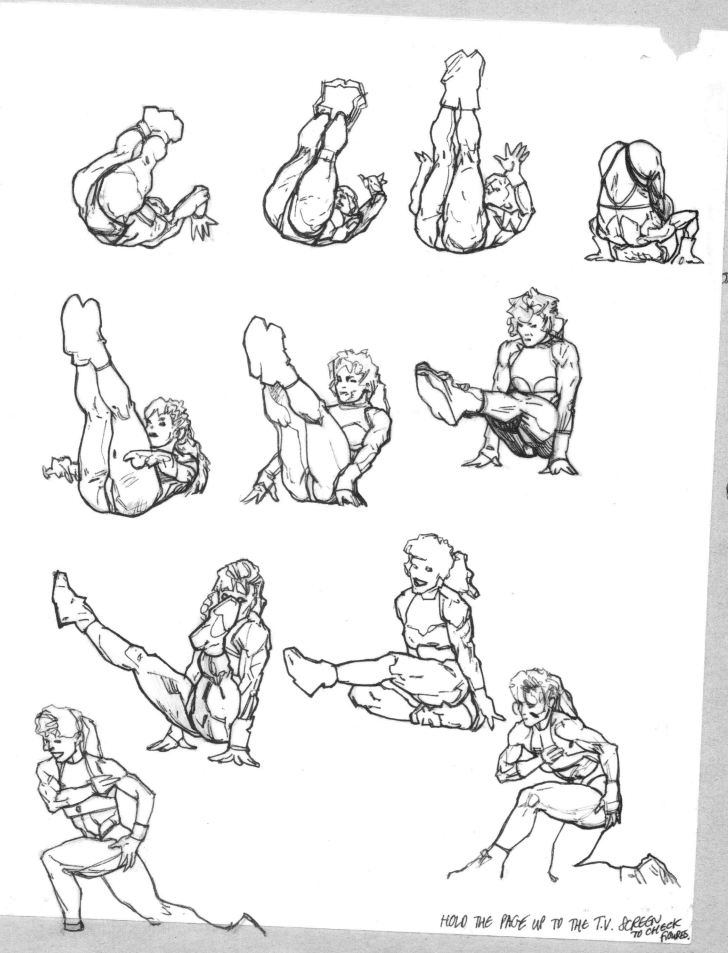

HOLD THE PAGE UP TO THE T.V. SCREEN TO CHECK FIGURES.

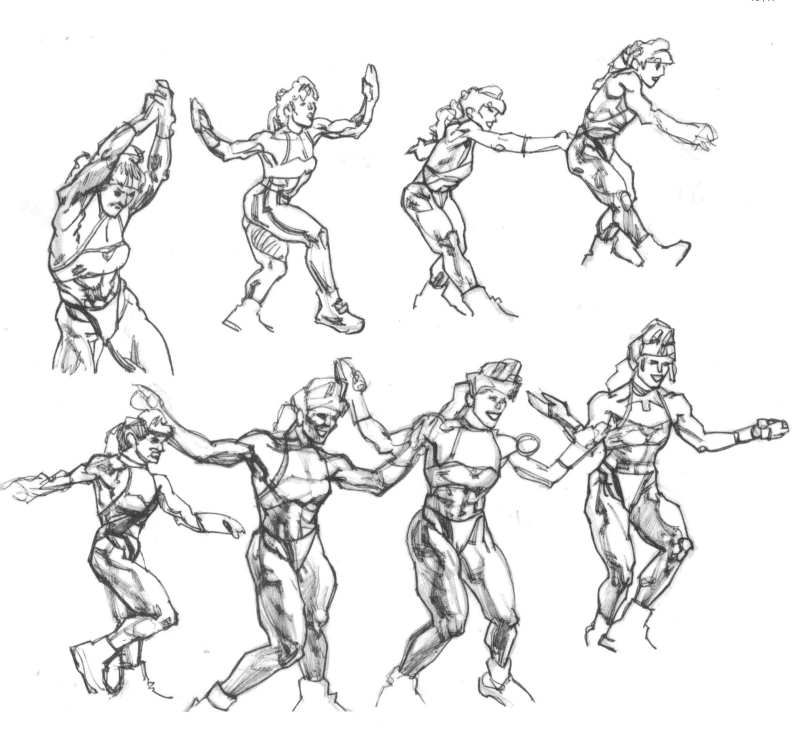

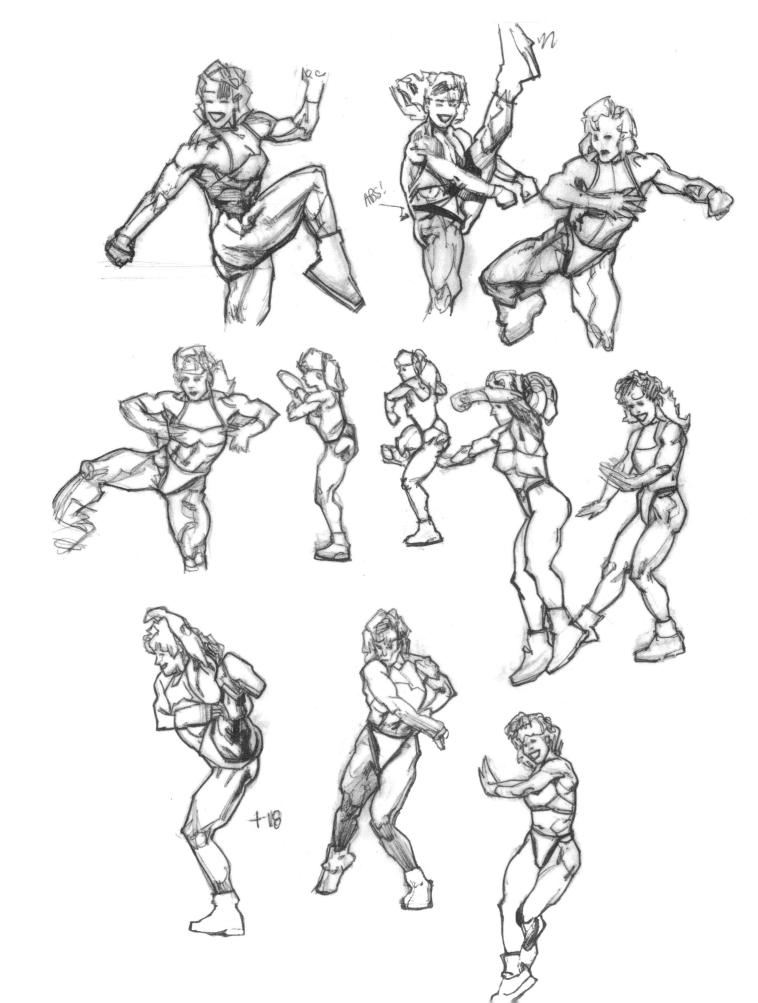

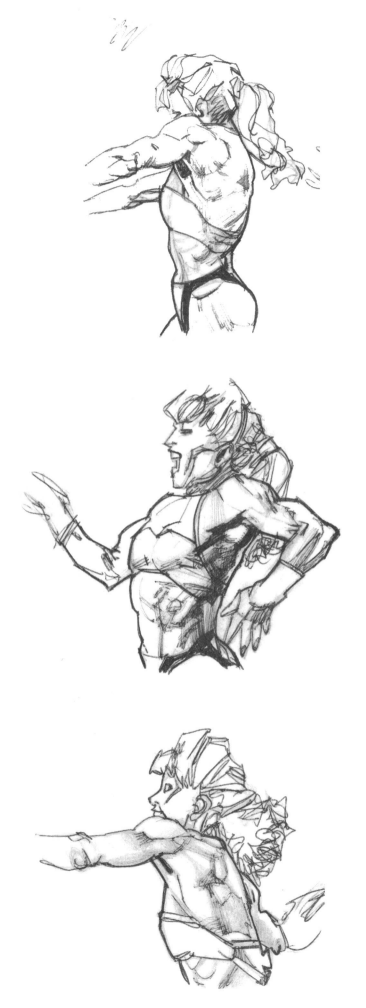

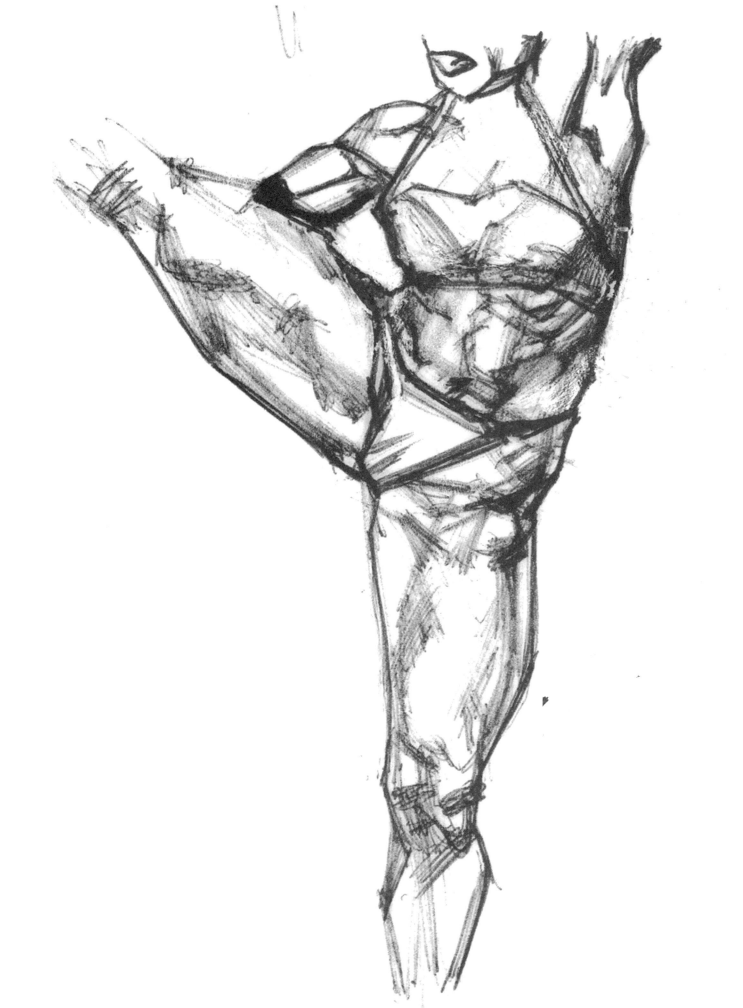

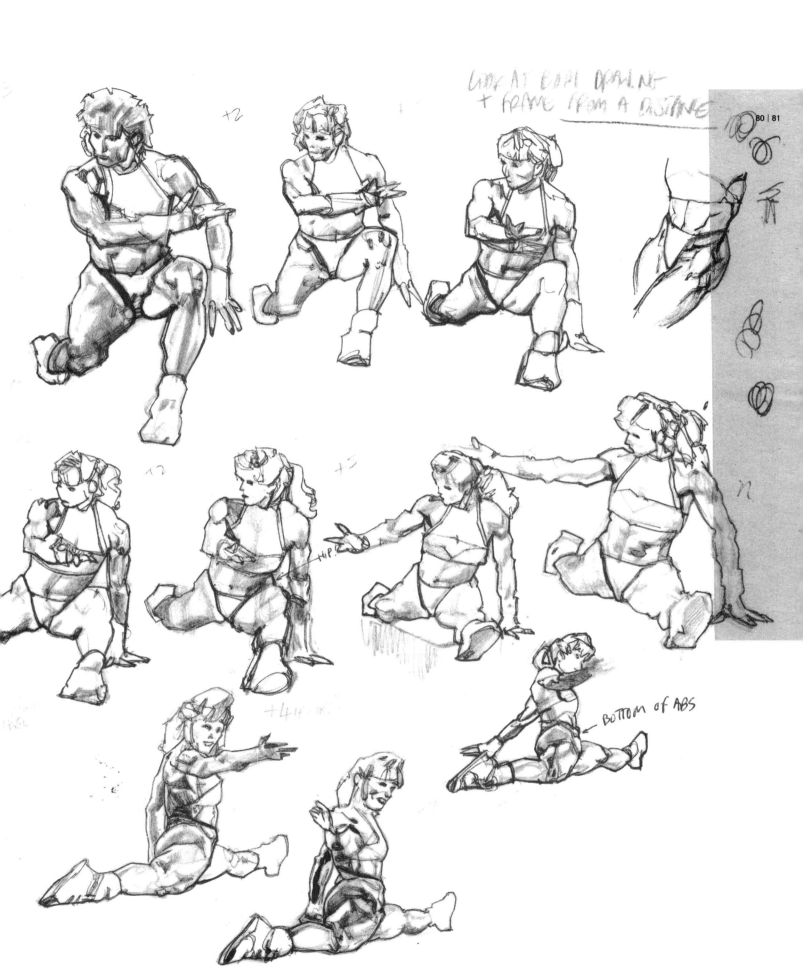

LOOK AT BODY DRAWING
+ FRAME FROM A DISTANCE

+2

+2

+5

HIP!

+4 IN DR.

BOTTOM OF ABS

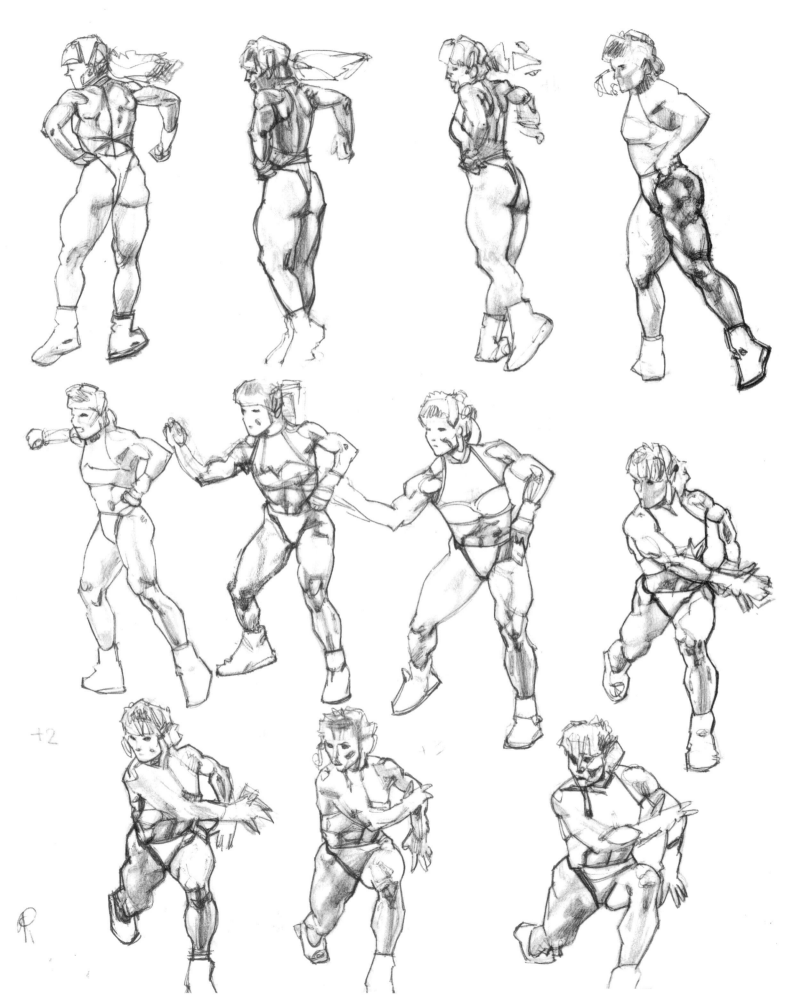

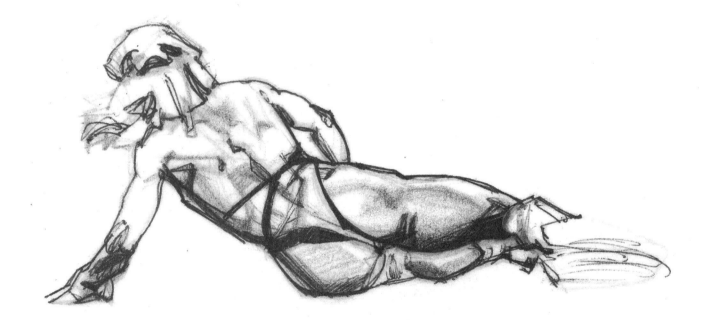

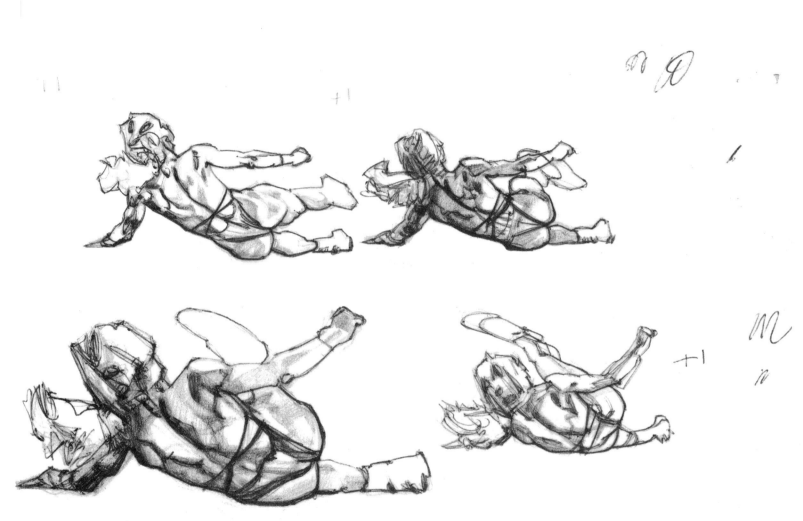

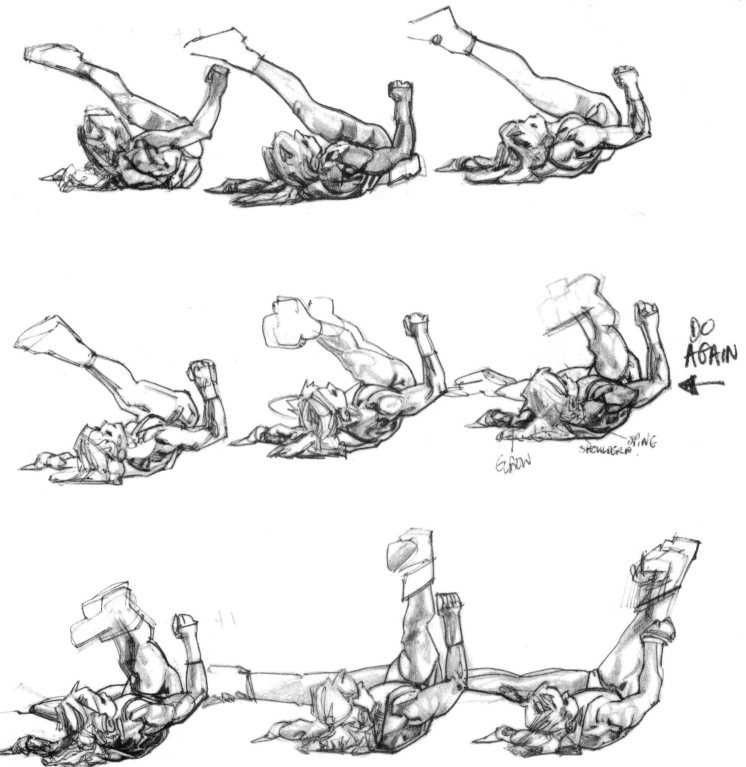

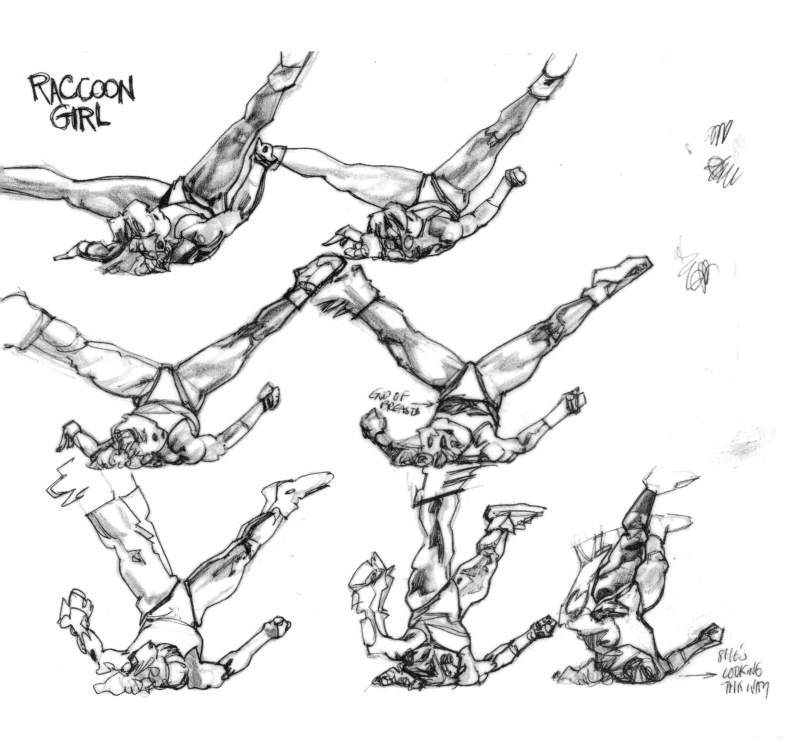

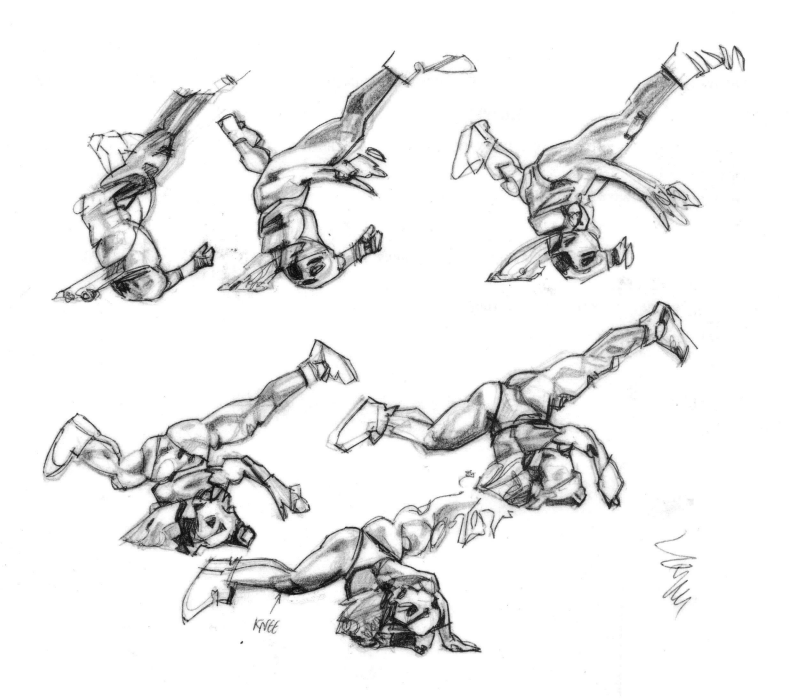

KNEE

PAGAN FRED FABRY

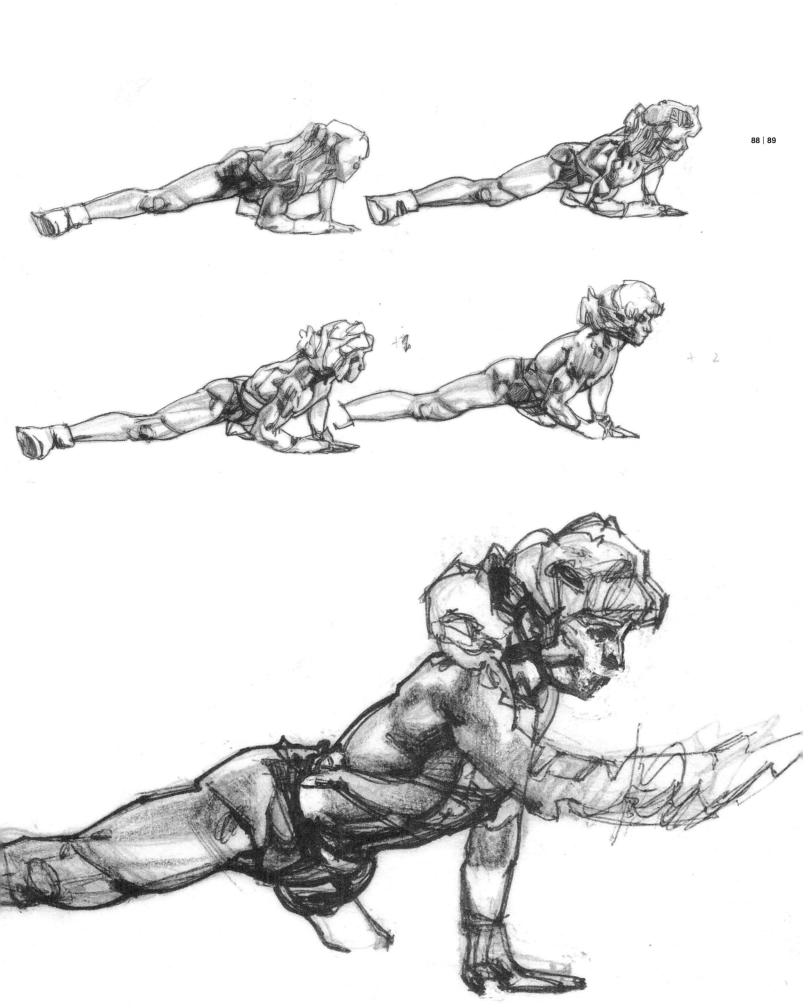

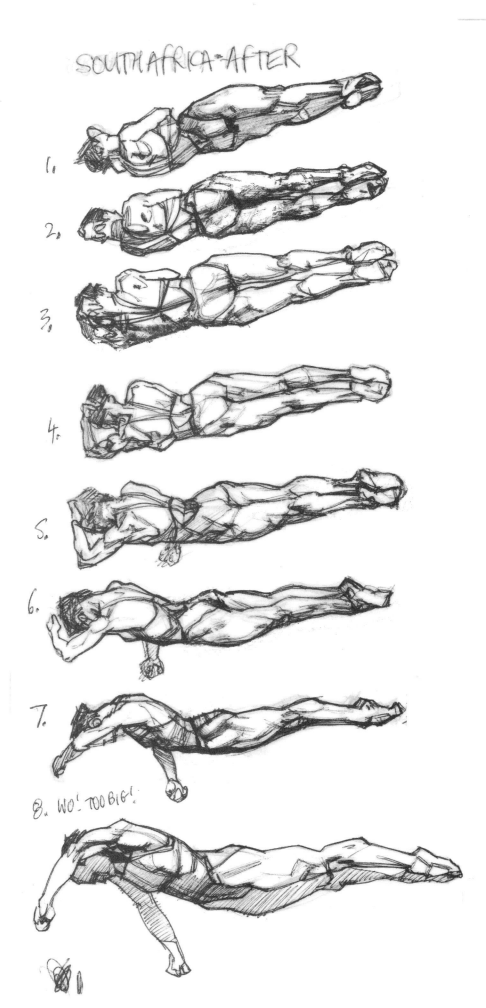

SOUTH AFRICA AFTER

1.

2.

3.

4.

5.

6.

7.

8. WO! TOO BIG!

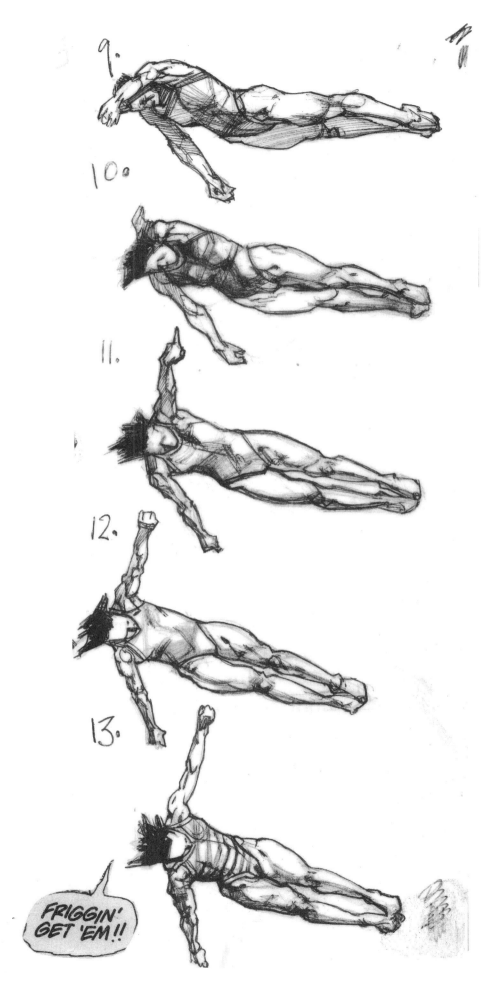

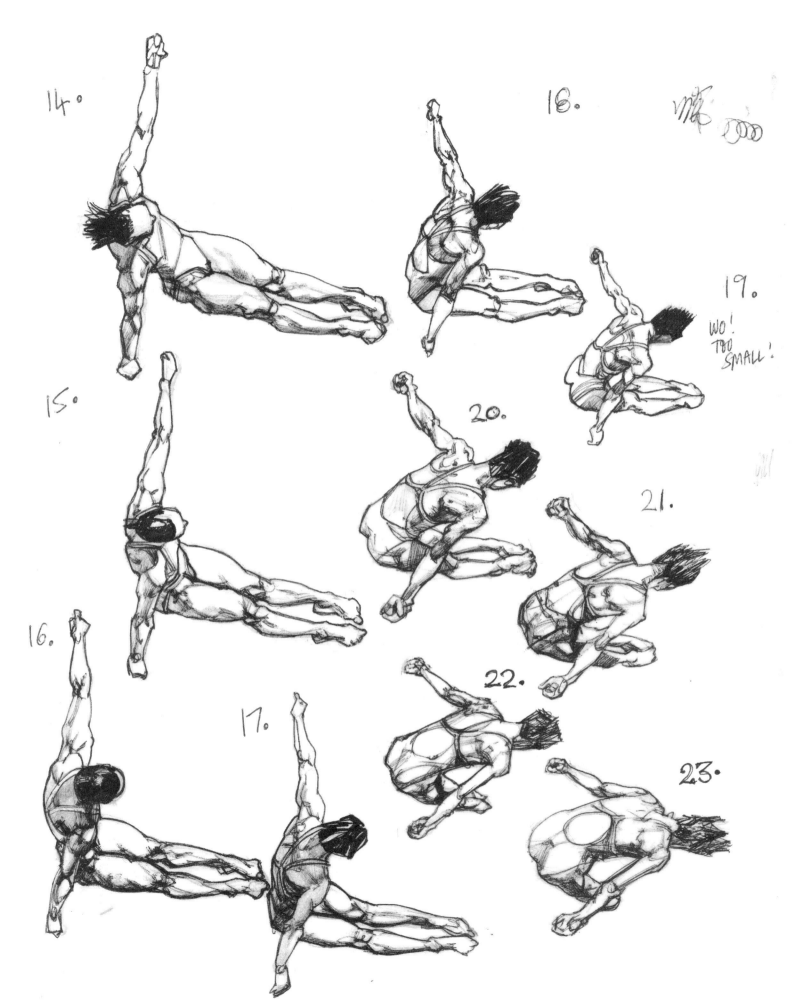

24.

25.

25 AGAIN!
AAAGH!!!...

25 AGAIN, THE BASTARD!

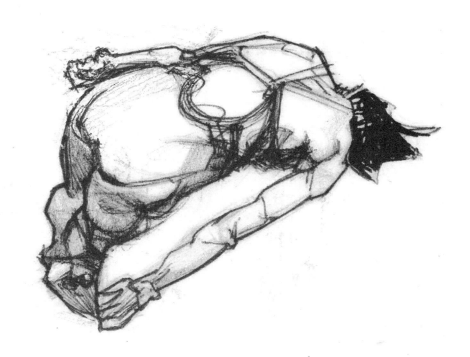

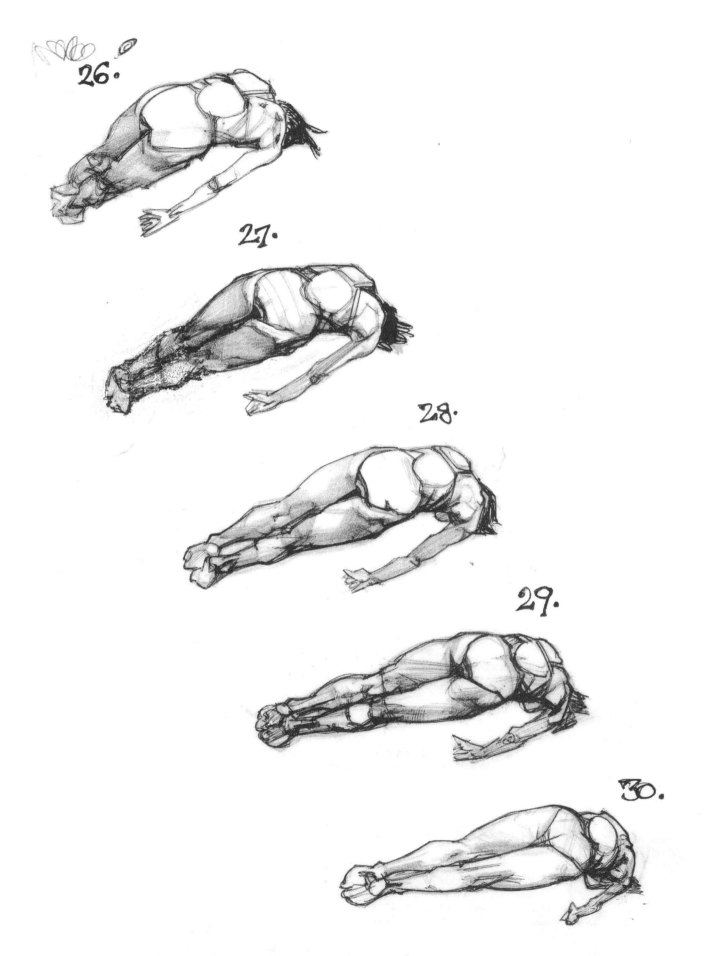

26.

27.

28.

29.

30.

Line of Action

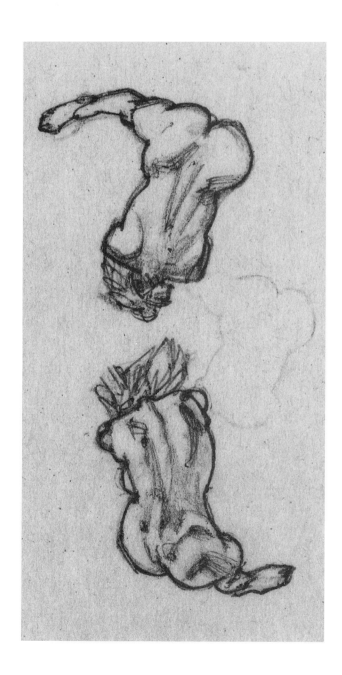

The line of action indicates momentum that propels the human figure along its course of movement. Put down your pencil for a moment and imagine this invisible line on a figure doing a jump, a forward dive, and a backflip.

In a jump, for example, the line stretches from the base of thee feet to the outstretched tips of the fingers. Think of it as a kind of washing line to hang the body onto. It's helpful to establish this line from your very first pencil strokes and to bear it in mind as you continue with your picture. Since our goal is to capture the figure in motion, this is very important.

Quite often there's ore than one line of action, just as there can be more than one light source. A good way to draw people falling or being knocked over is to send one line of action off one way and the other in the opposite direction, so you completely upset your character's balance.

However, don't try to include too many lines of action in one figure, as it will diminish the impact of your drawing. Keep it to one or two. A large part of your drawing consists of your intentions and thought processes as you draw. Even very slight differences in thickness or direction of line can add volumes to the final effect of the piece.

The line of action is an abstract concept, but draw it into a preliminary sketch to help you put dynamism into your drawing. By the time you get to the final stages of your drawing, you will erase the line.

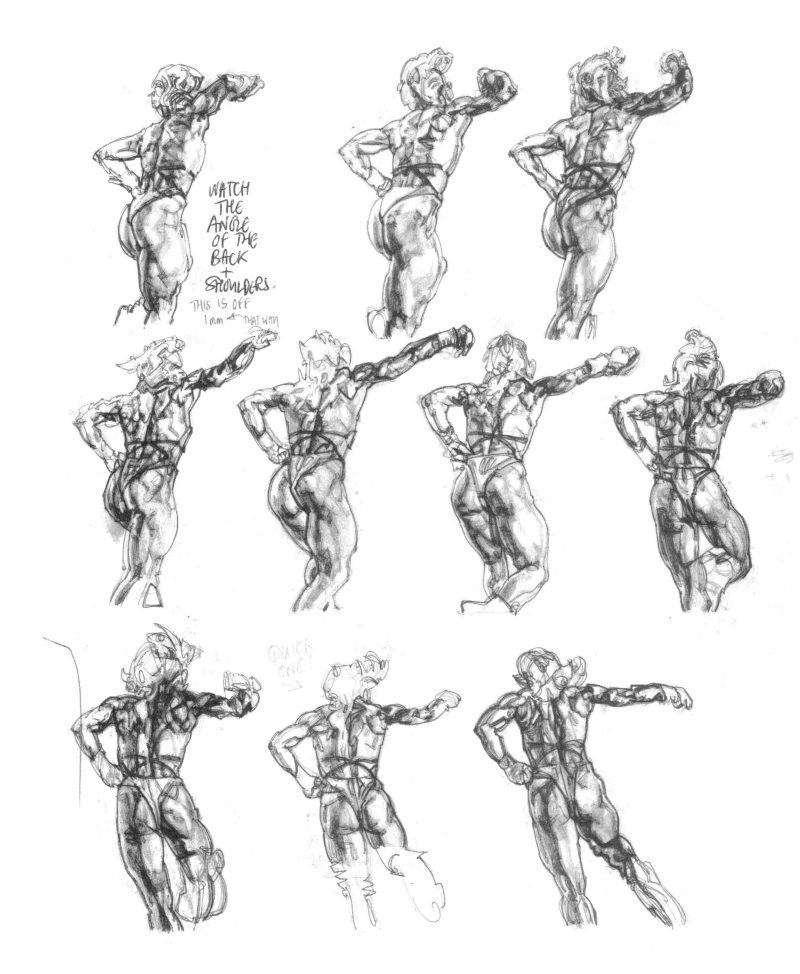

WATCH
THE
ANGLE
OF THE
BACK
+
SHOULDERS.

THIS IS OFF
1mm ↚ THAT WAY

QUICK
ONE!
→

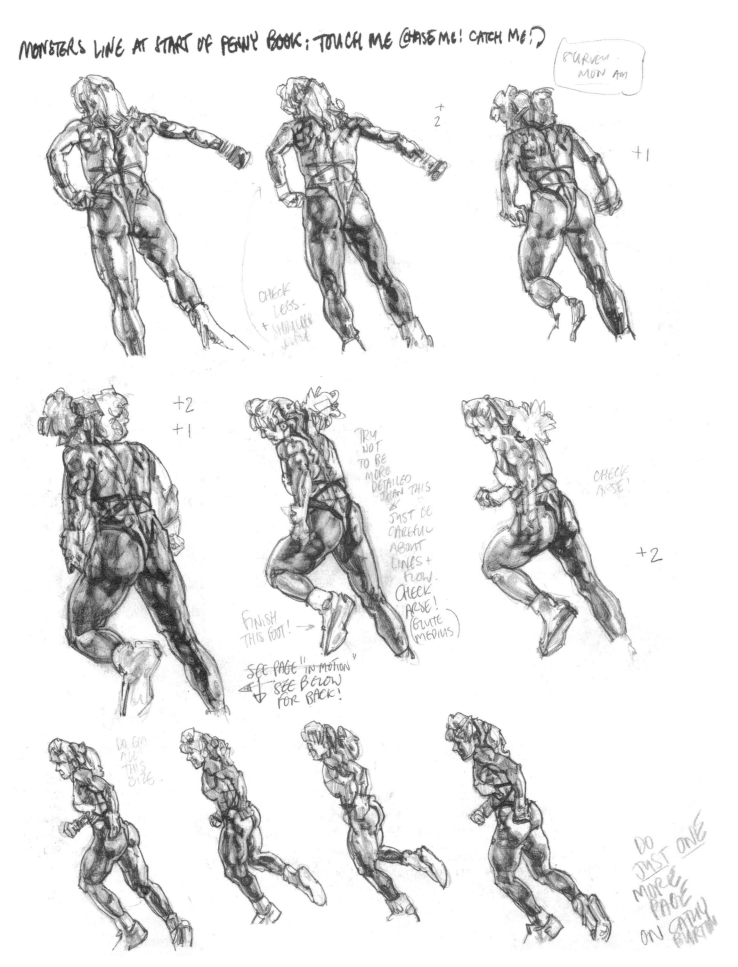

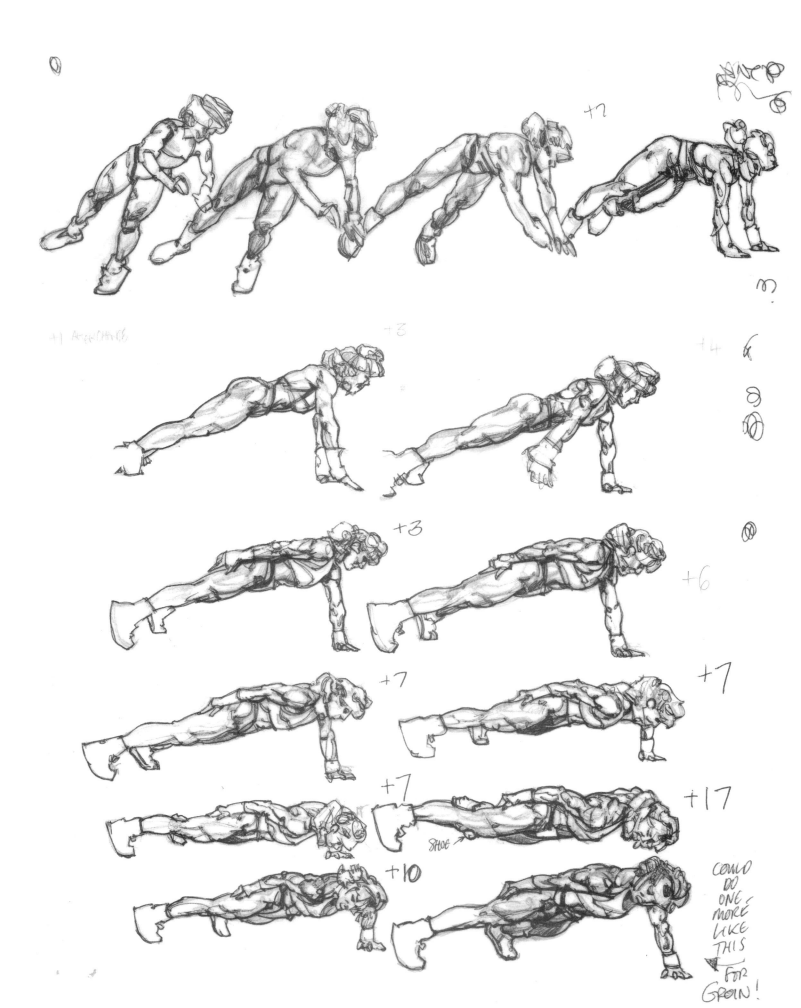

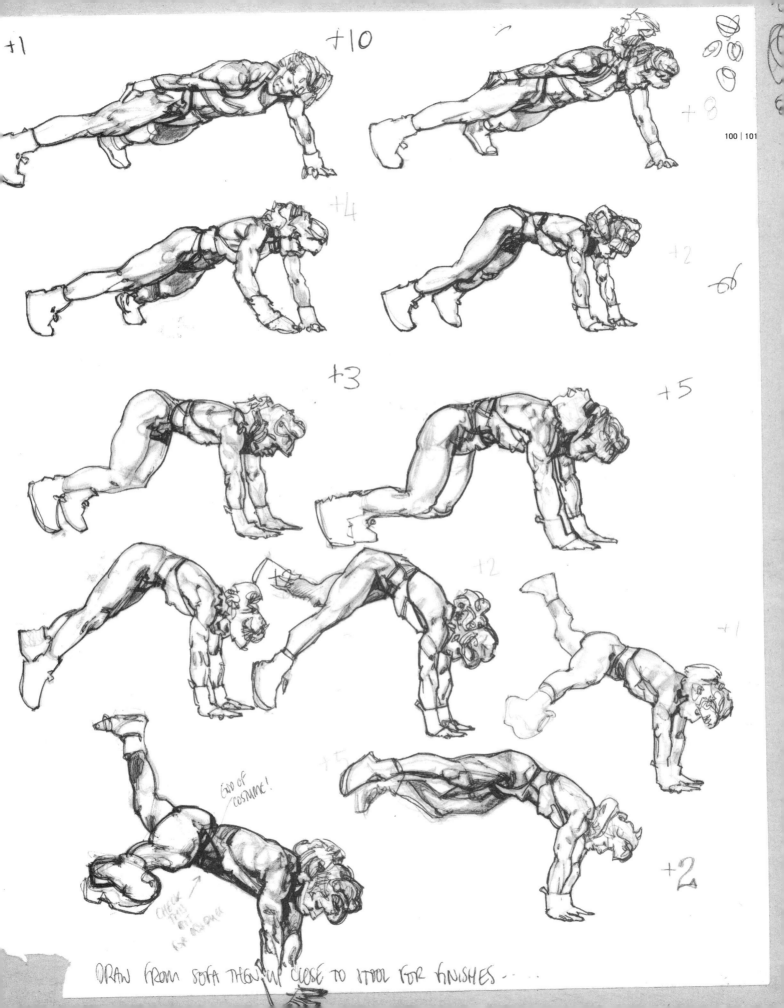

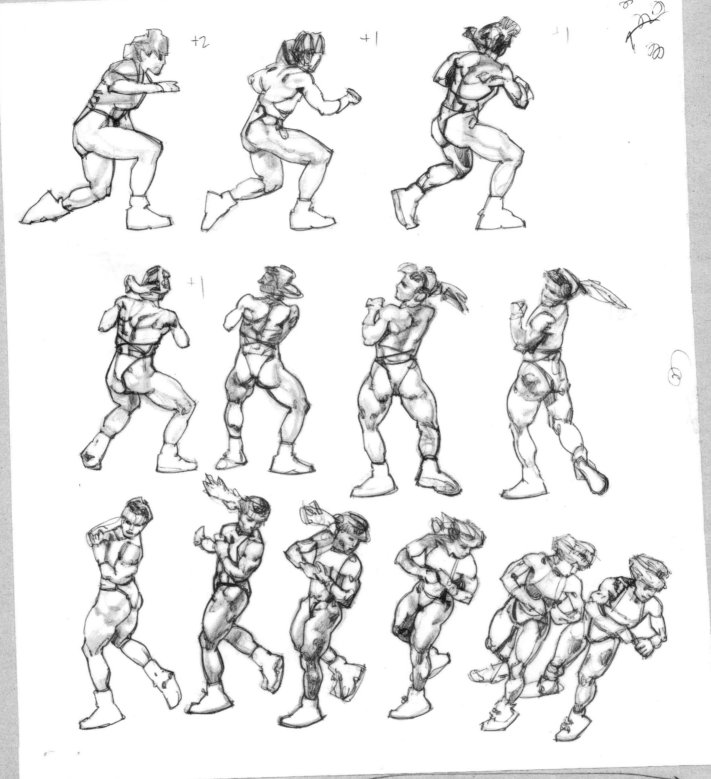

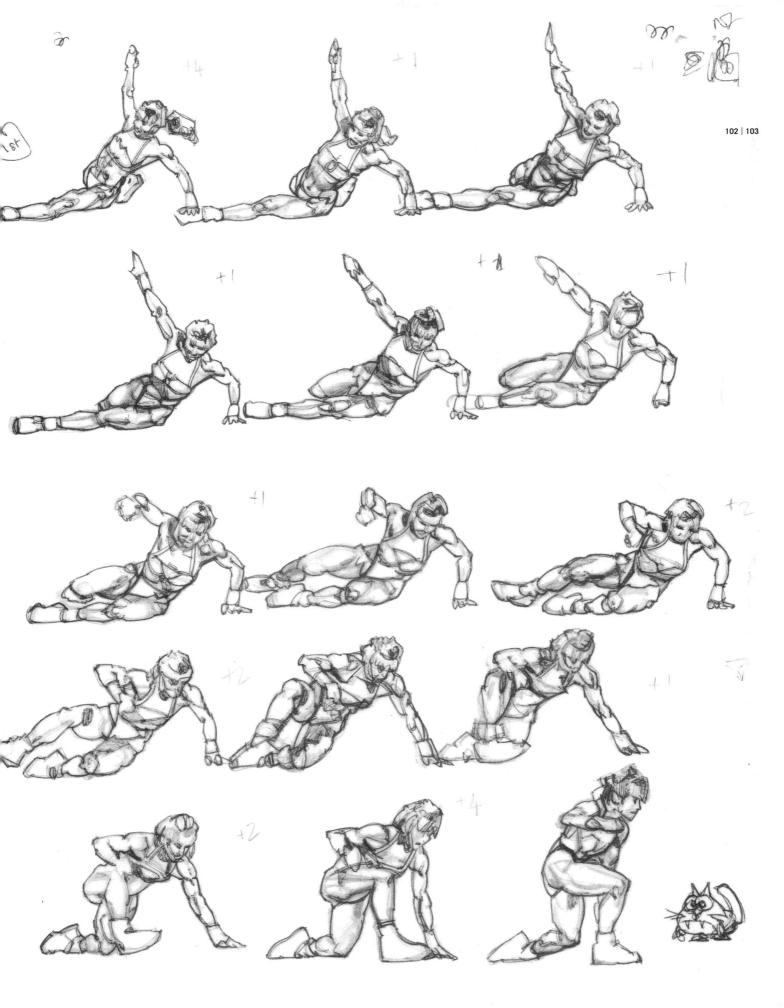

CHECK THIS LEG

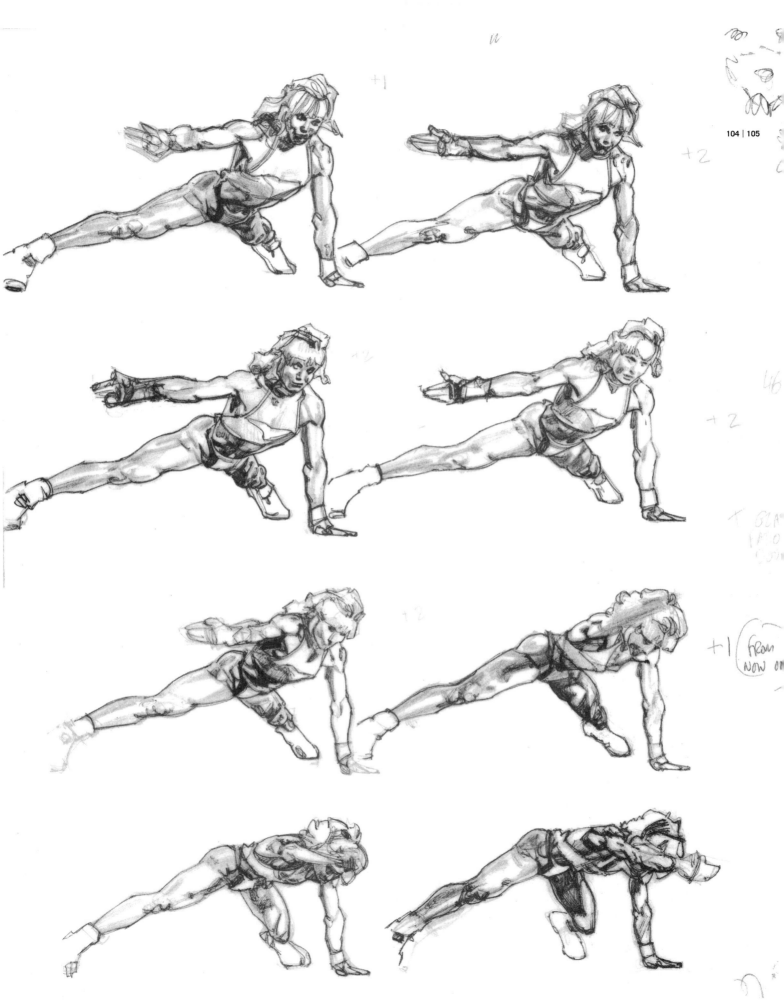

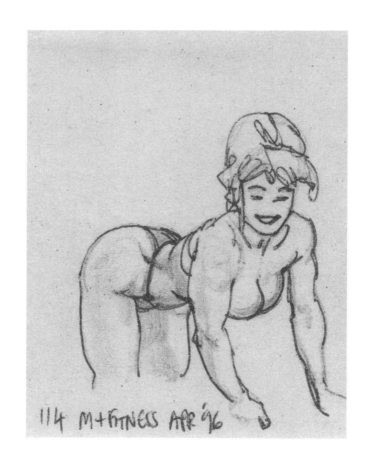

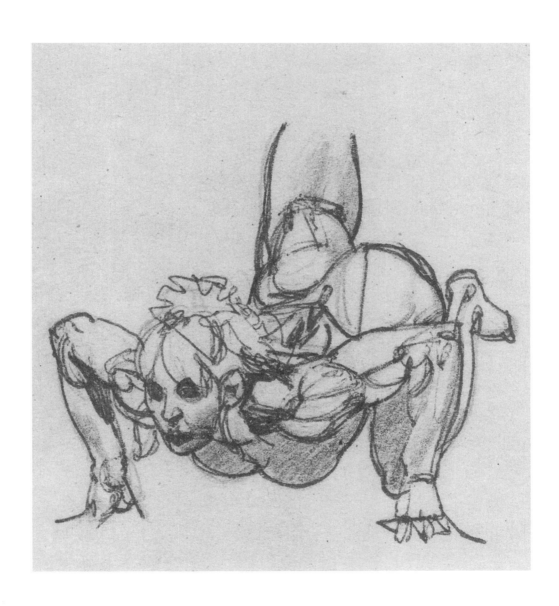

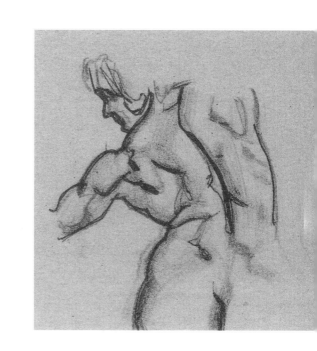

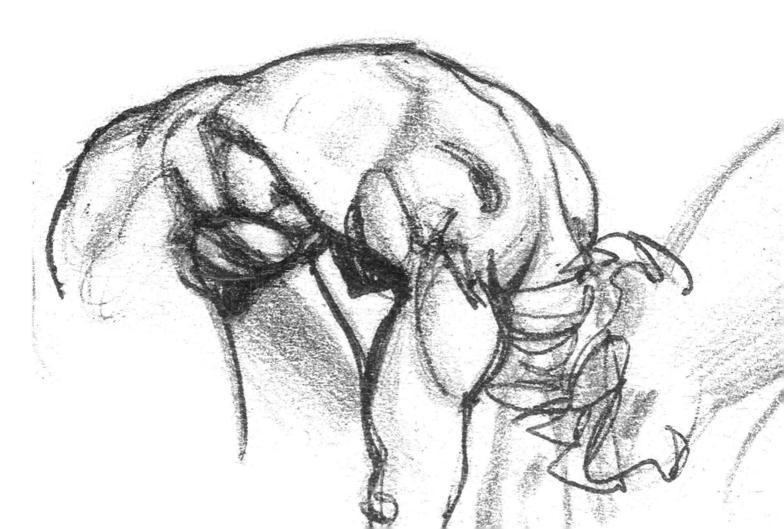

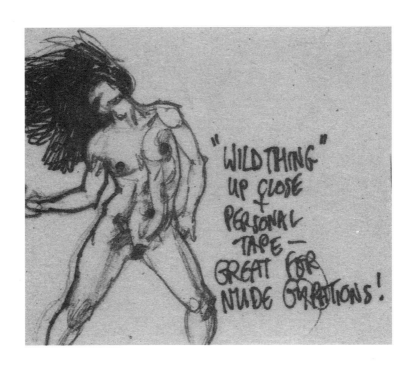

"WILD THING"
UP CLOSE
&
PERSONAL
TAPE —
GREAT FOR
NUDE GYRATIONS!

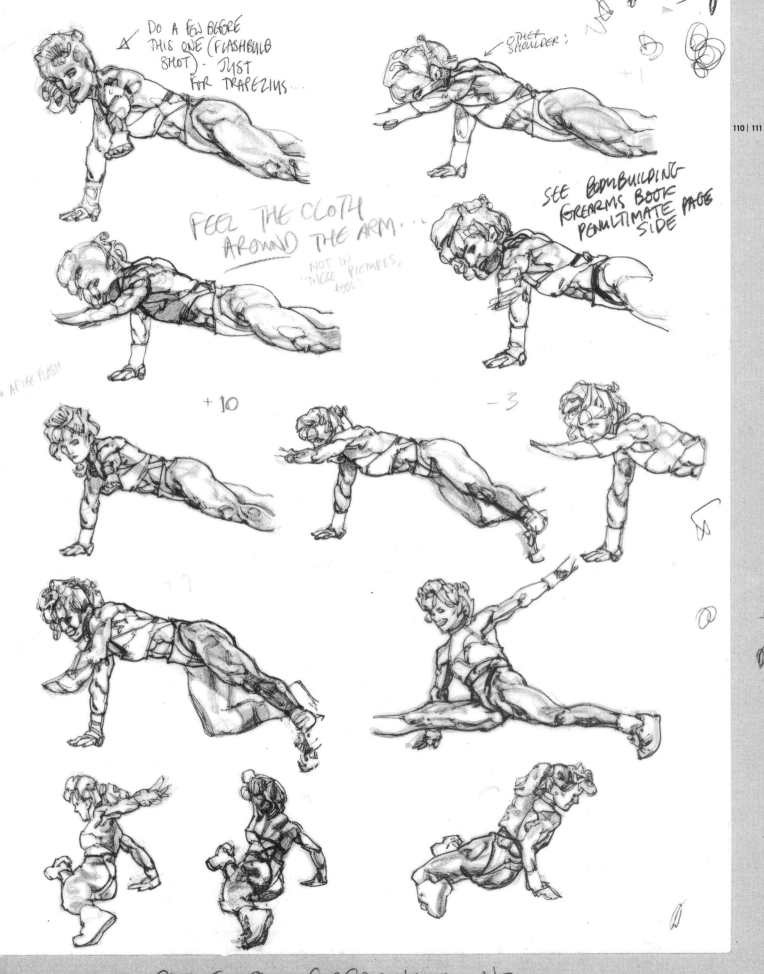

DO A FEW BEFORE THIS ONE (FLASHBULB SHOT)- JUST FOR TRAPEZIUS...

OTHER SHOULDER

SEE BODYBUILDING FOREARMS BOOK PENULTIMATE SIDE PAGE

FEEL THE CLOTH AROUND THE ARM...

NOT IN THESE PICTURES, FOOL!

AFTER FLASH

+ 10

- 3

+ 9

SEE PAGE 19 OF PREACHER # 2.1

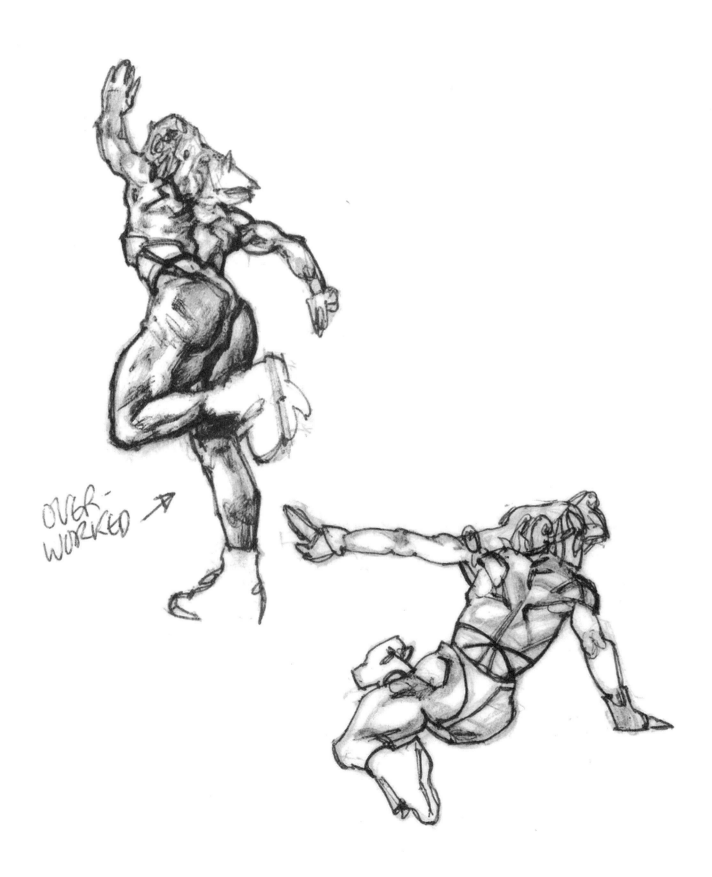

OVER-
WORKED →

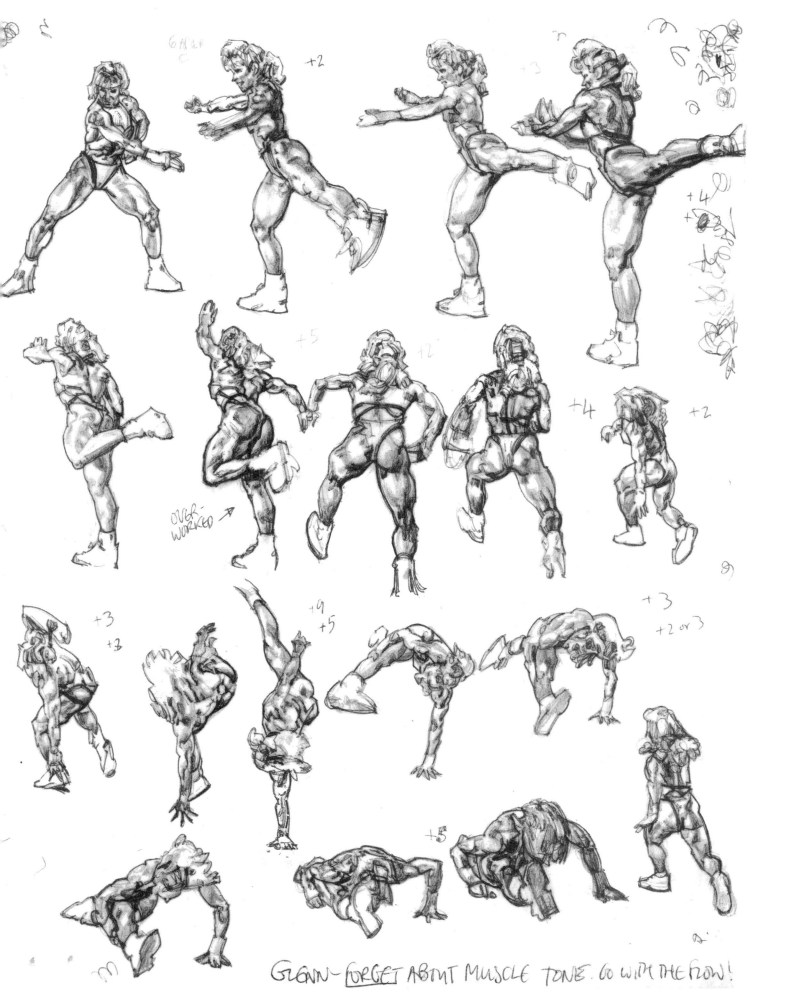

GLENN-FORGET ABOUT MUSCLE TONE. GO WITH THE FLOW!

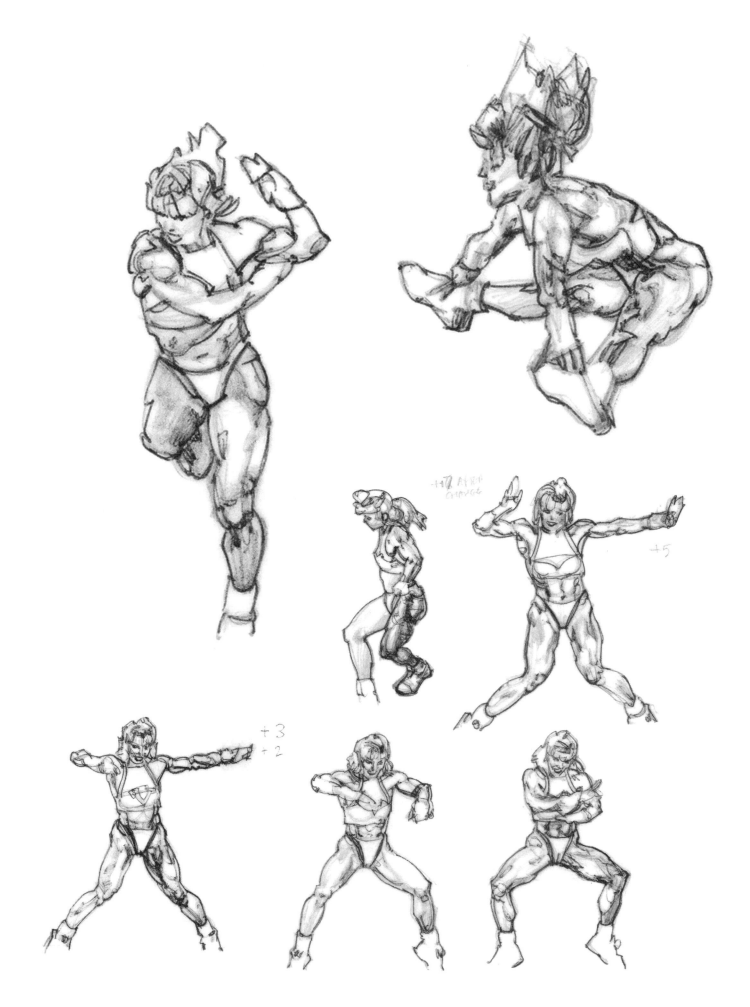

4

3

+5
+7

+4

+5

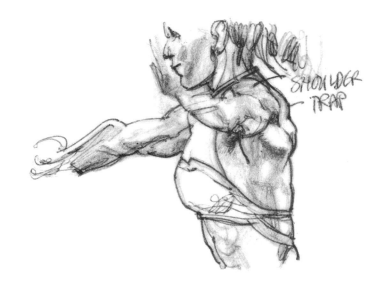

SHOULDER
TRAP

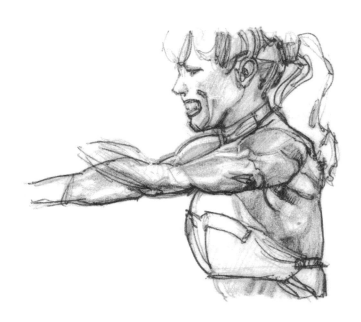

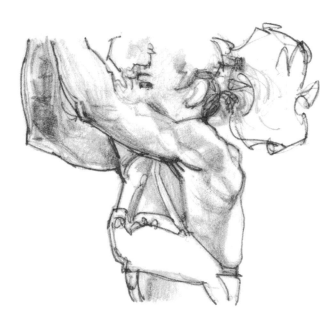

THEN ONLY THE
CLEAR ONES

+ 1,

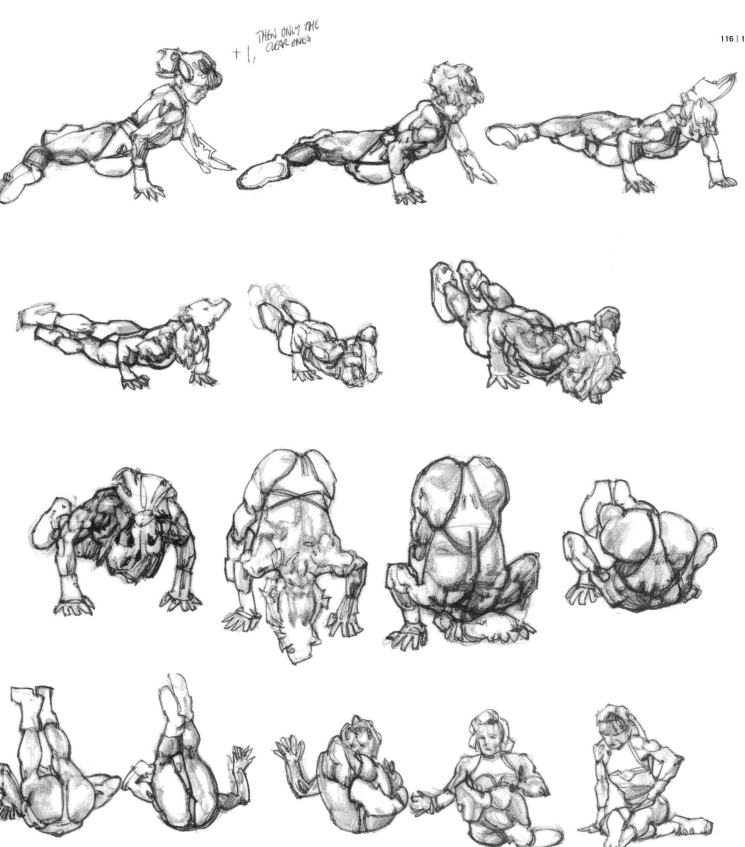

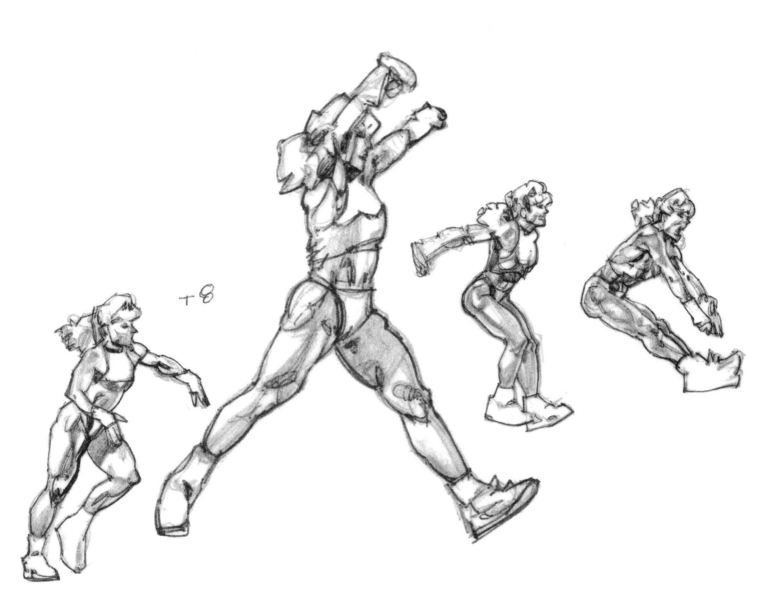

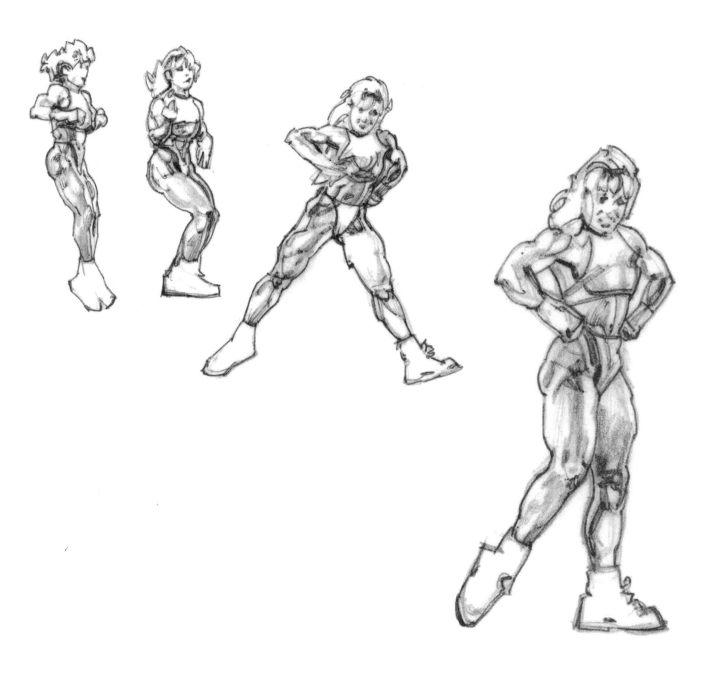

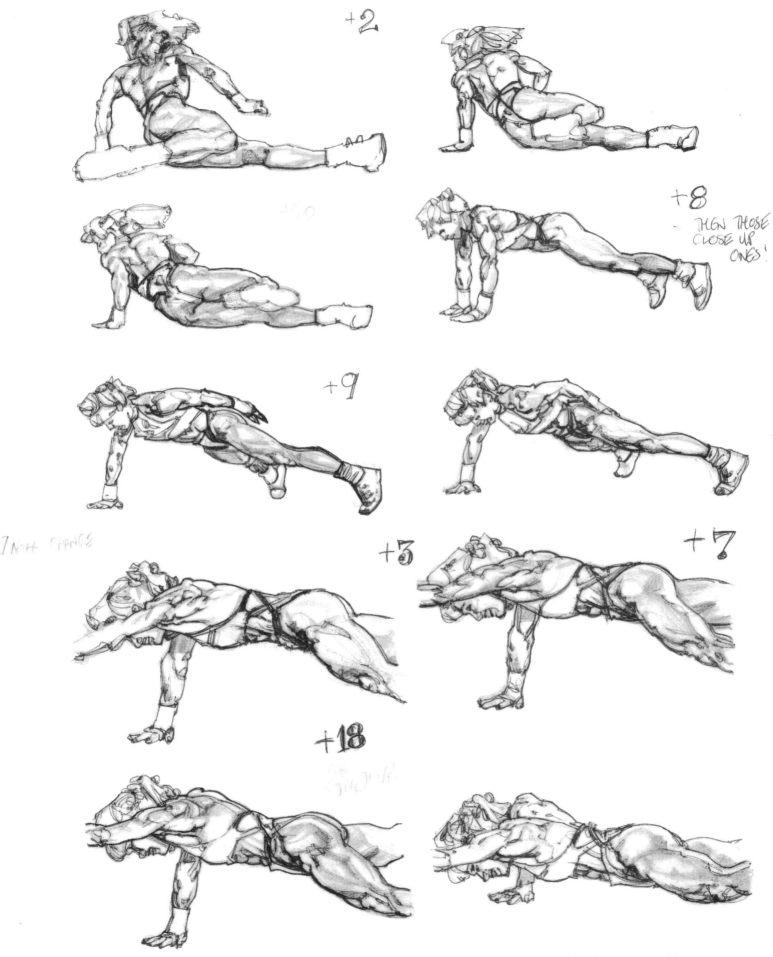

+2

+8

THEN THOSE
CLOSE UP
ONES!

+9

INTER CHANGE

+5

+7

+18

DON'T DO ANYMORE ANIMATION STUFF ON THIS GIRL...

+1

+3

+6

+1

+3

Working from reference

All of the drawings in this book were drawn from reference for the purpose of being used as reference. None of them were traced or projected. I used the freeze-frame feature on my video player and sat across the room drawing from it. It's not as satisfying as drawing from life, but since you can't freeze a live person in mid-action, it has to do.

When you are drawing a subject, whether it be a live person or a video image, you can judge the angle of the line you're trying to draw by holding up either a plumb line or horizontal line in front of your subject. A plumb line is a line from which a weight is suspended, used by builders and carpenters to determine if something vertical is aligned.

You can use a ruler or a pencil to gauge a horizontal line, or instead of a plumb line to gauge a vertical line. This is how it's done Hold your pencil in front of you at arm's length. If you're right-handed, close your left eye. If you're left-handed, close your right eye. Hold the pencil in a fist, then raise your thumb in the "thumb's up" position. Allow two inches of pencil to rise higher than your thumb.

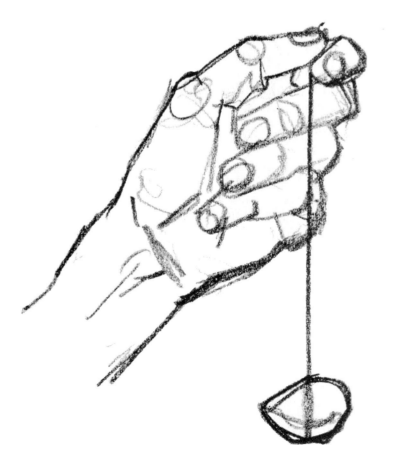

A plumb line is an exact vertical line that can be made by holding a weighted piece of string.

Alternatively, you can use the side of your pencil.

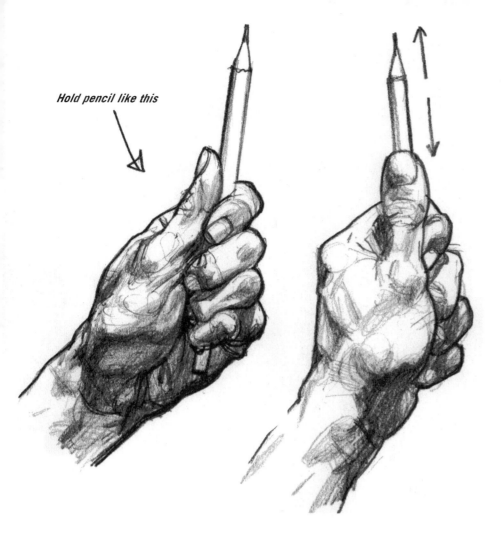

Hold pencil like this

Measure a pose using your pencil.

Hold your arm out in front of you and measure the subject at this constant distance.

You can change the length by placing your thumb higher or lower on the pencil.

To draw from a live model, you can use this method to establish correct proportions. Suppose you start with the model's head. Hold up your pencil at arm's length, and use the distance between the tip of the pencil and the top of your thumb as the length or width of the model's head. Then use this unit of measurement as the distance between the two furthest points of the head in your drawing.

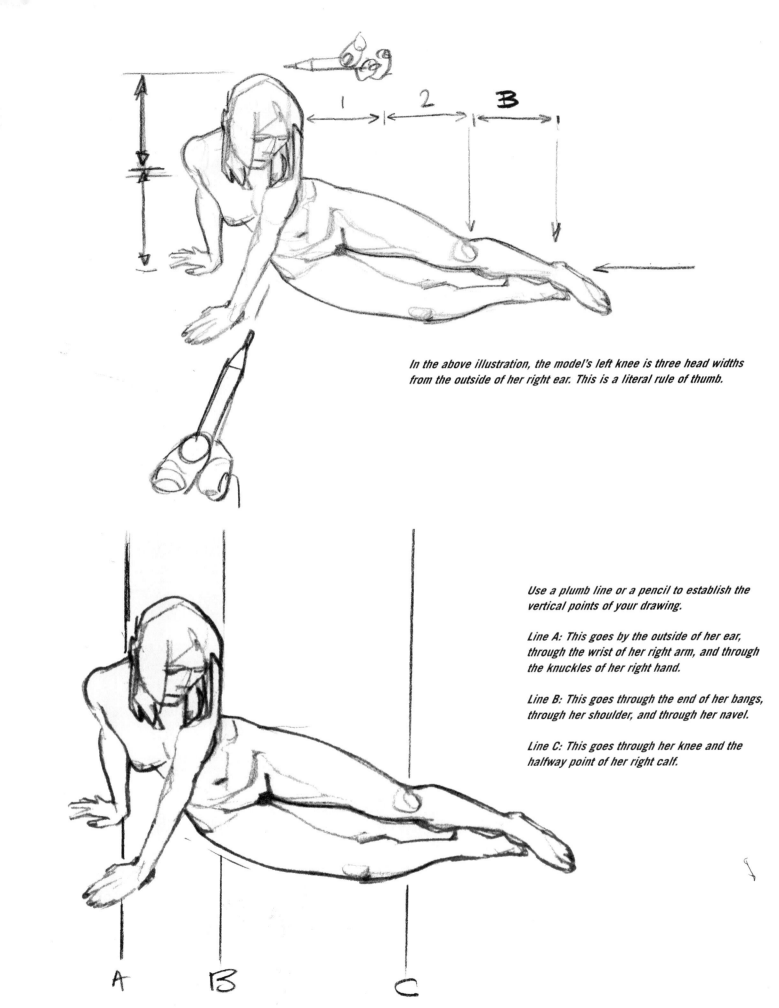

In the above illustration, the model's left knee is three head widths from the outside of her right ear. This is a literal rule of thumb.

Use a plumb line or a pencil to establish the vertical points of your drawing.

Line A: This goes by the outside of her ear, through the wrist of her right arm, and through the knuckles of her right hand.

Line B: This goes through the end of her bangs, through her shoulder, and through her navel.

Line C: This goes through her knee and the halfway point of her right calf.

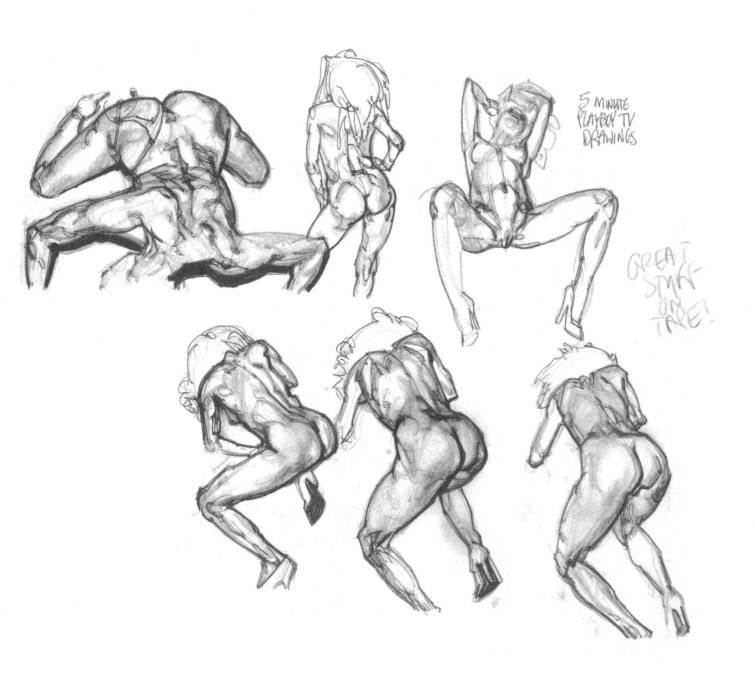

5 MINUTE
PLAYBOY TV
DRAWINGS

GREAT
STUFF
ON
TAPE!

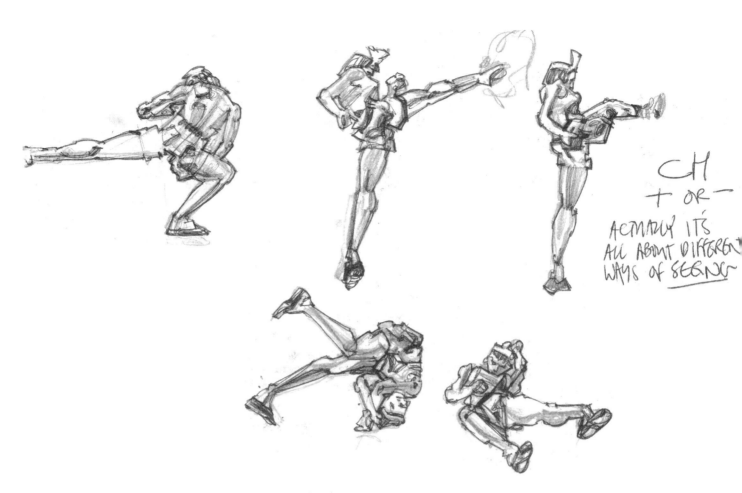

CH
+ or —

ACTUALLY ITS
ALL ABOUT DIFFERENT
WAYS OF SEEING

LIKE POOL — AIM TO GET NEAR THE POCKET.

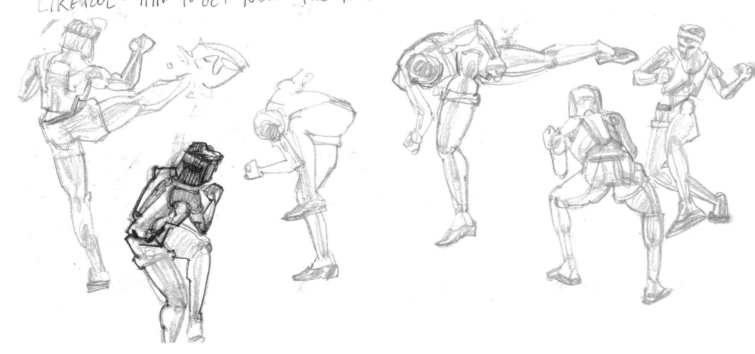

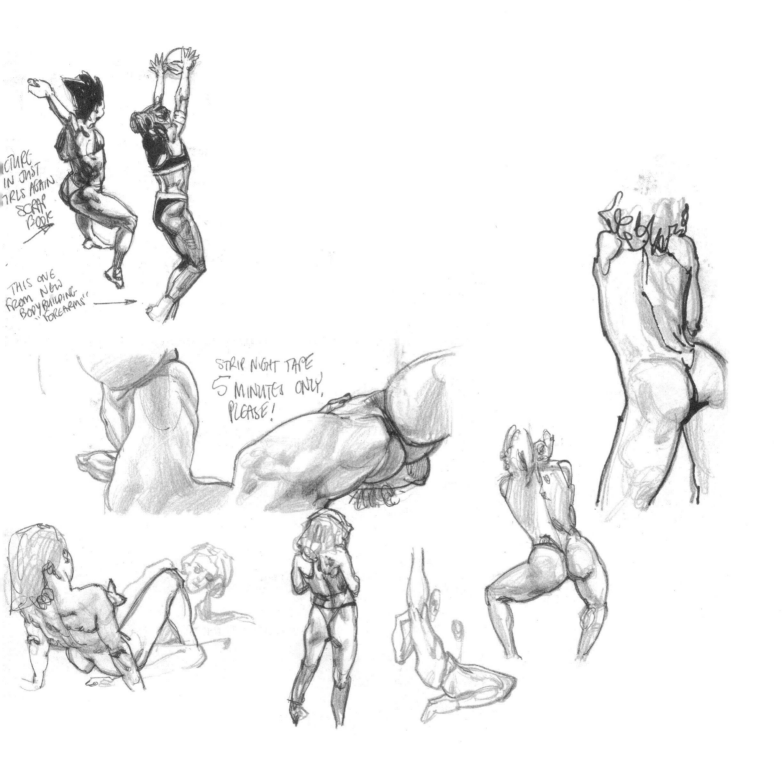

PICTURE
IN JUST
GIRLS AGAIN
SCRAP
BOOK

THIS ONE
NEW
FROM NEW
BODYBUILDING
"FOREARMS"

STRIP NIGHT TAPE
5 MINUTES ONLY,
PLEASE!

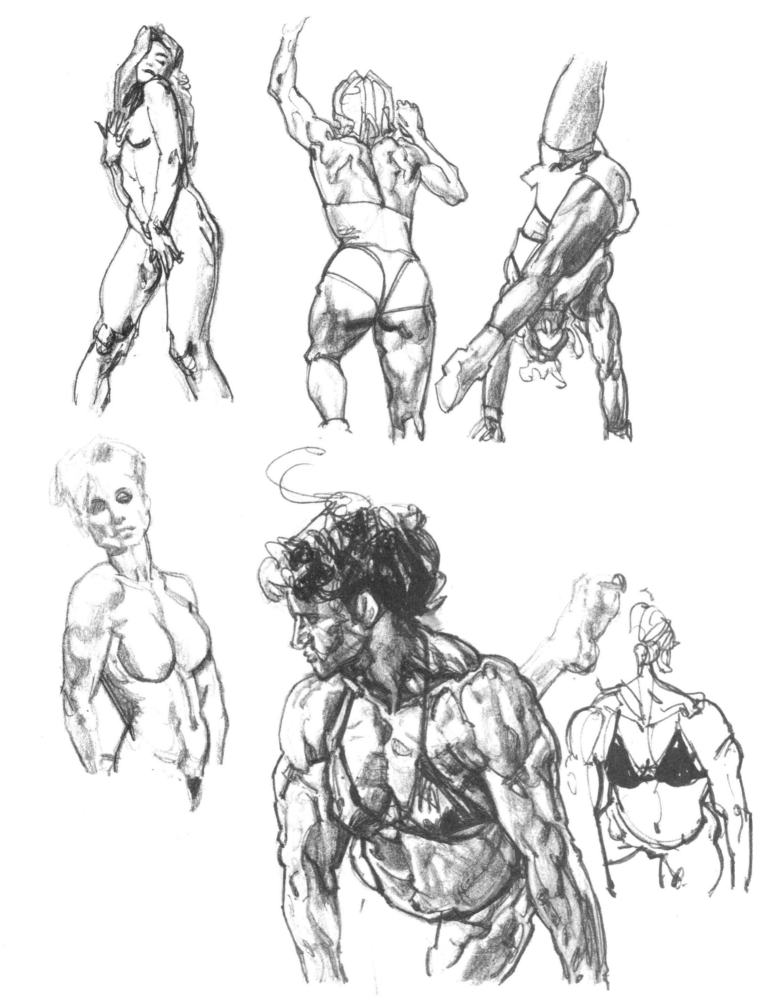

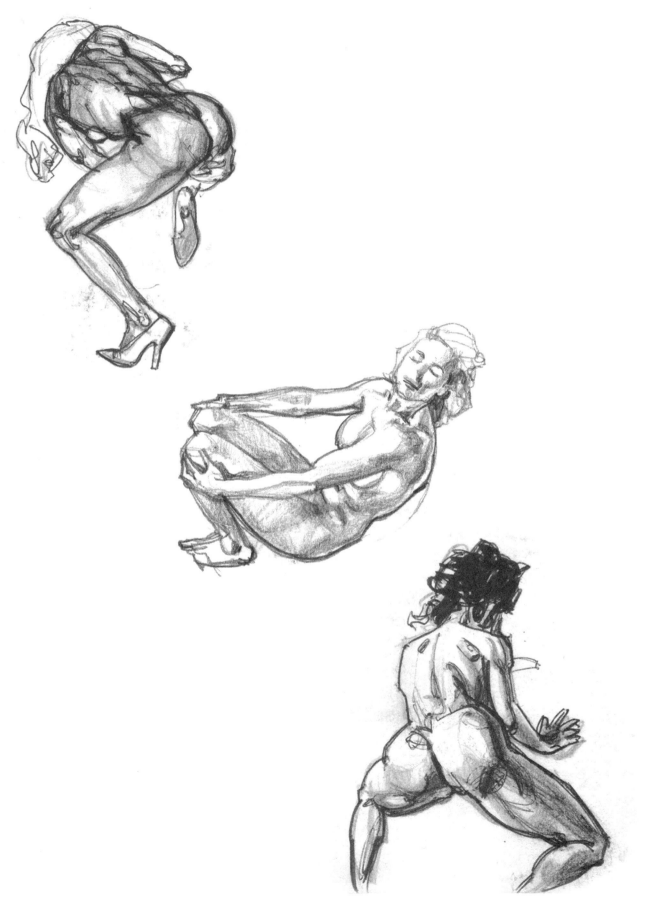

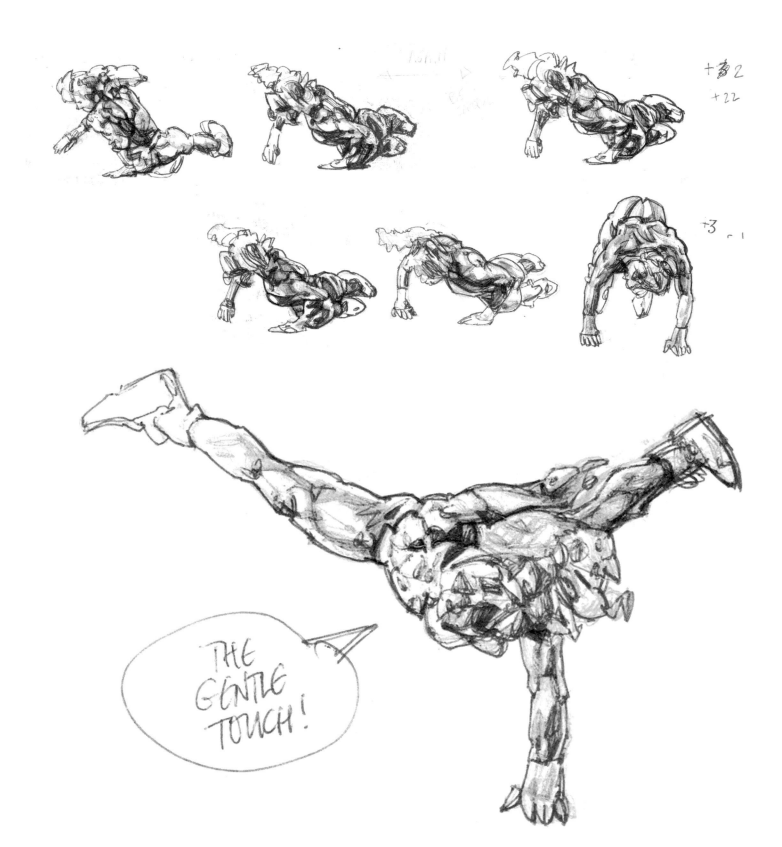

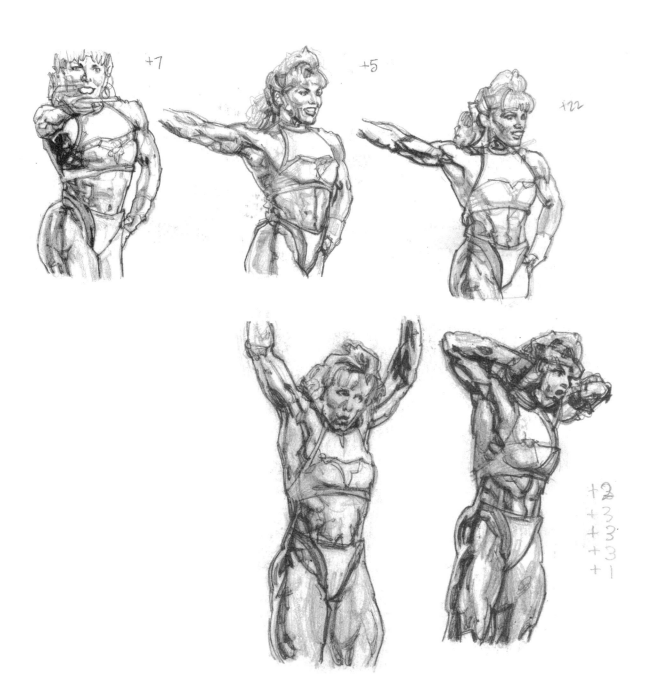

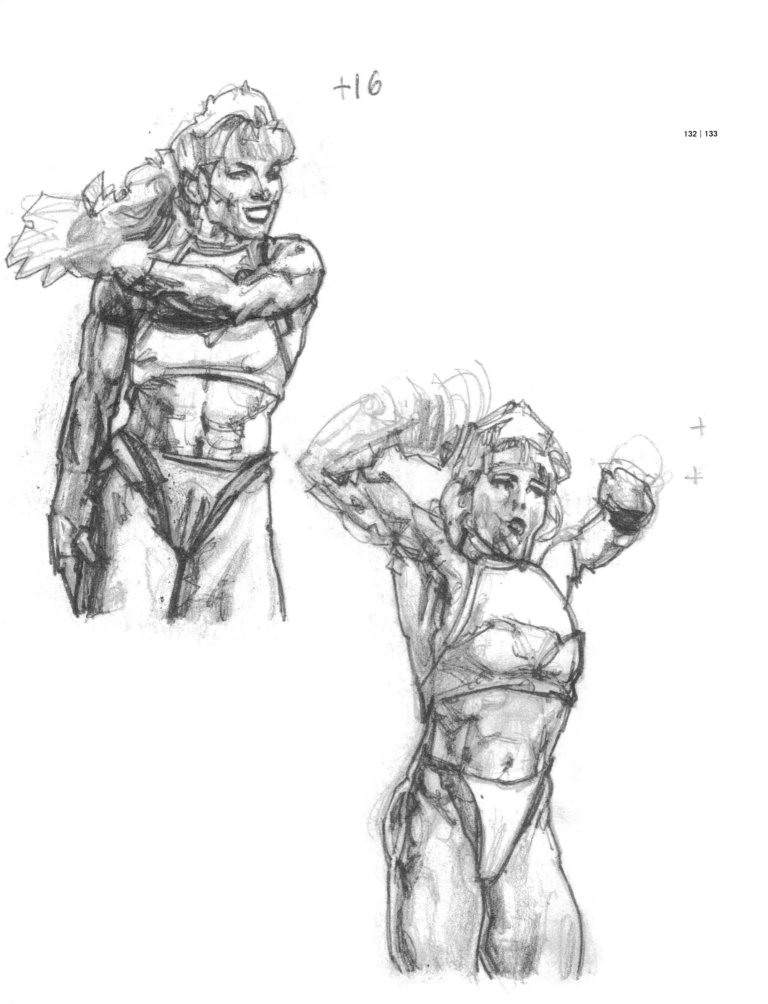

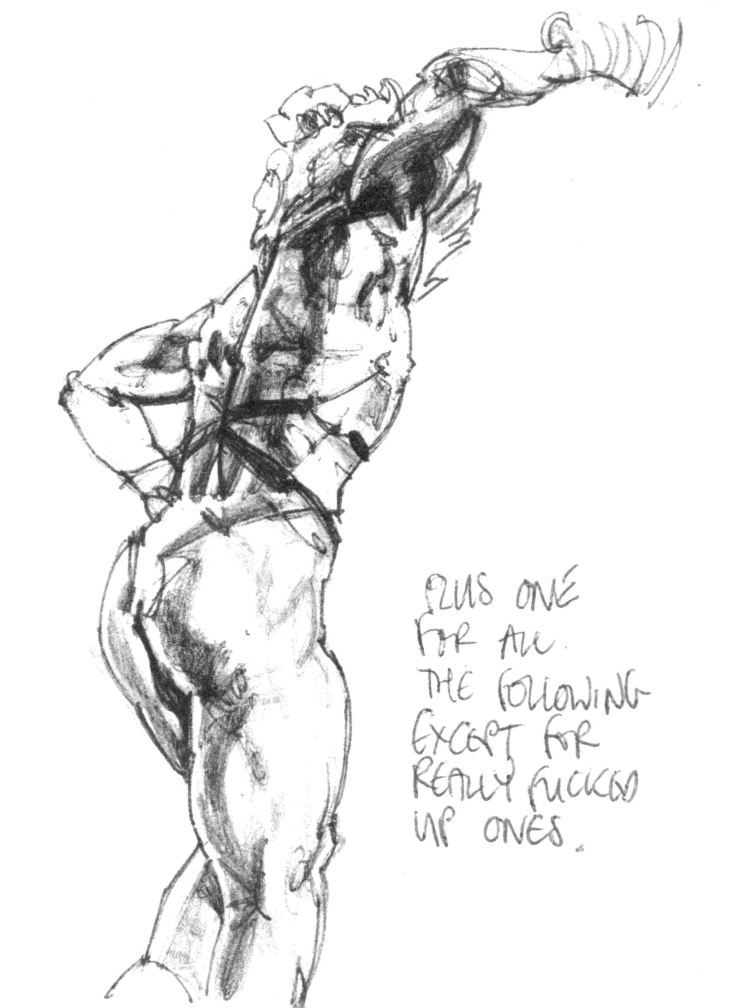

PLUS ONE
FOR ALL.
THE FOLLOWING
EXCEPT FOR
REALLY FUCKED
UP ONES.

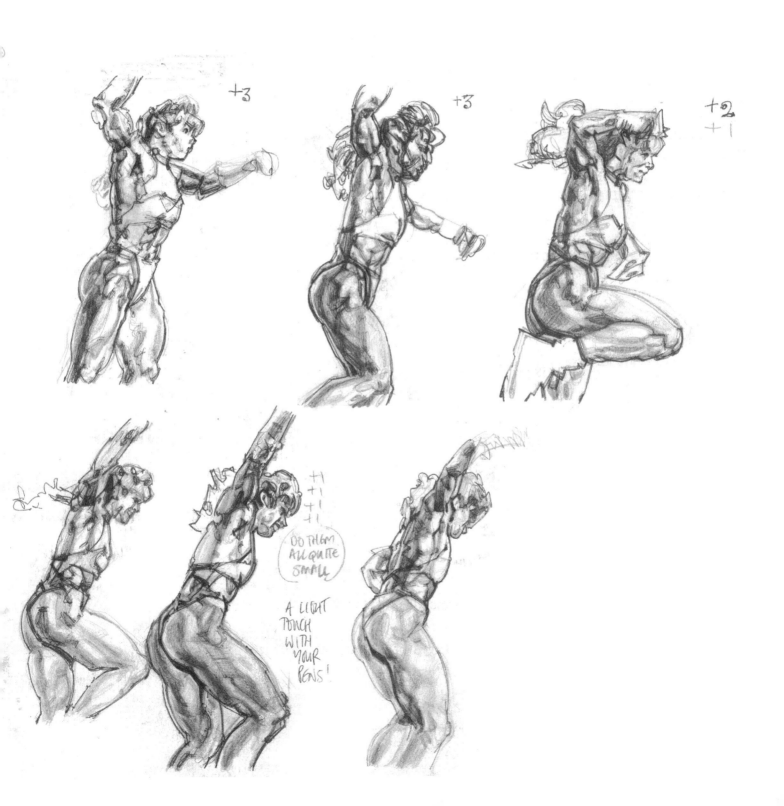

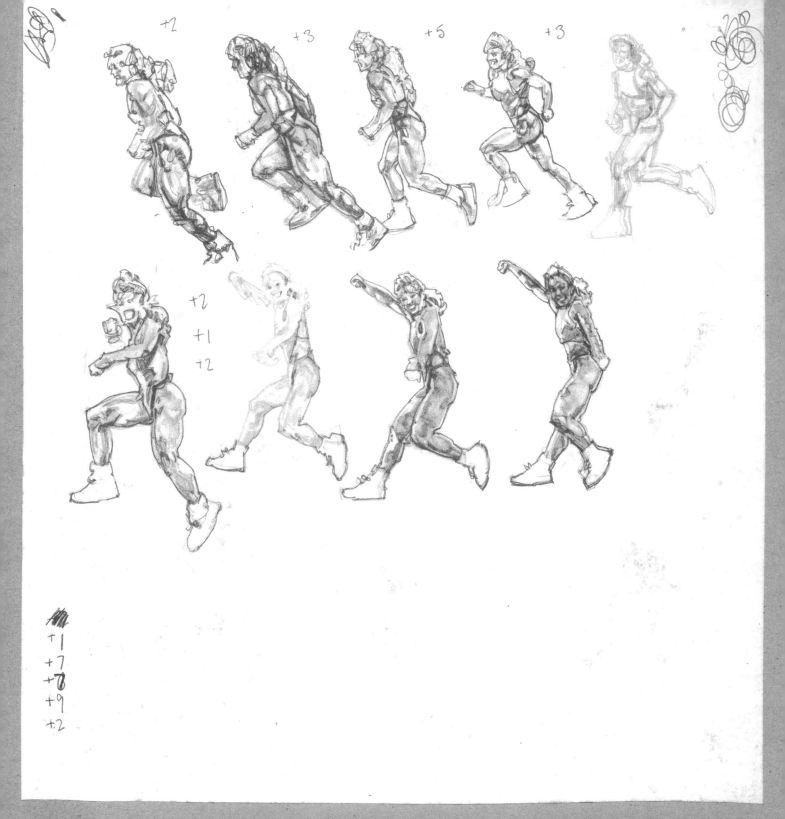

+2 +3 +5 +3

+2
+1
+2

+1
+7
+8
+9
+2

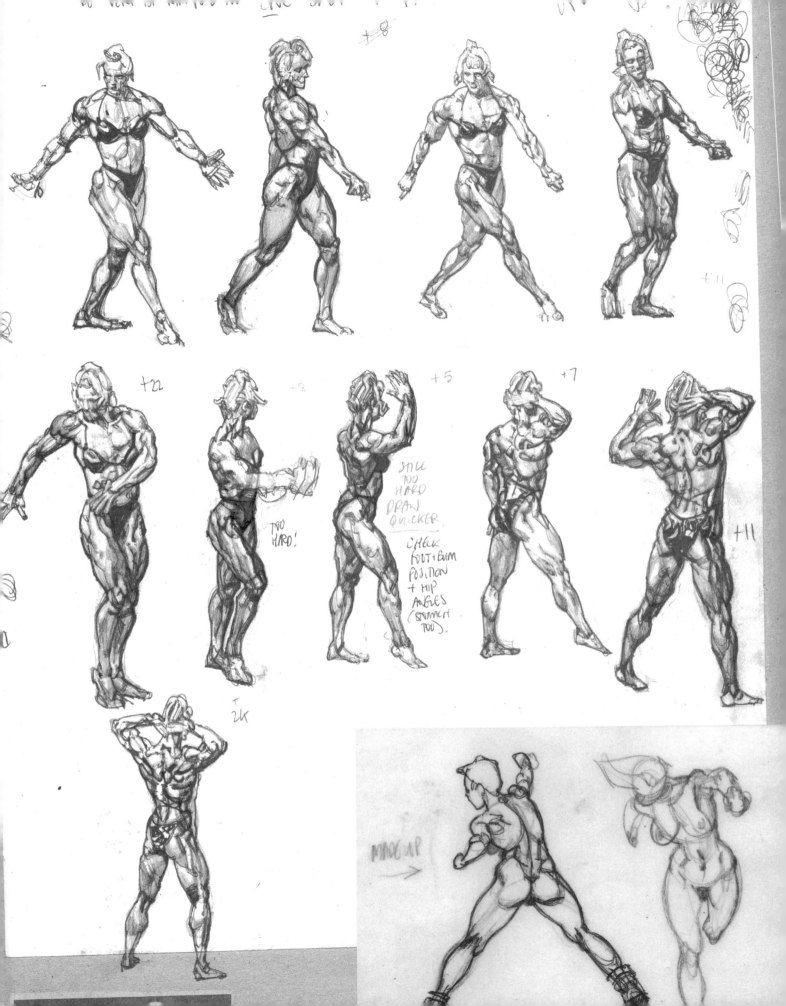

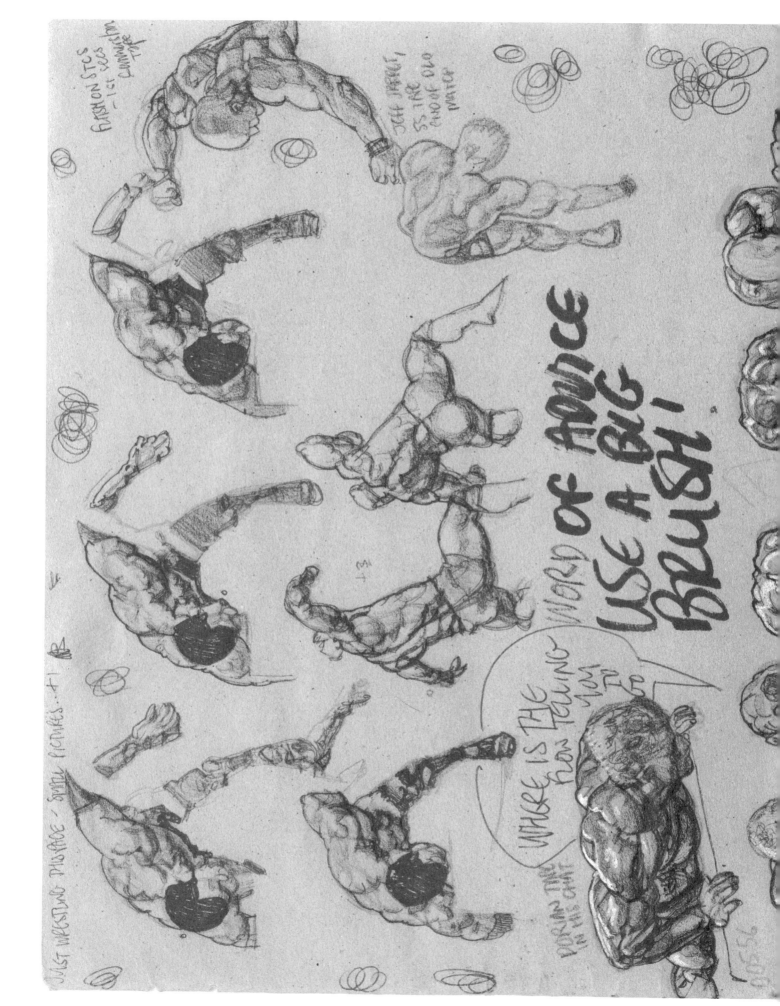

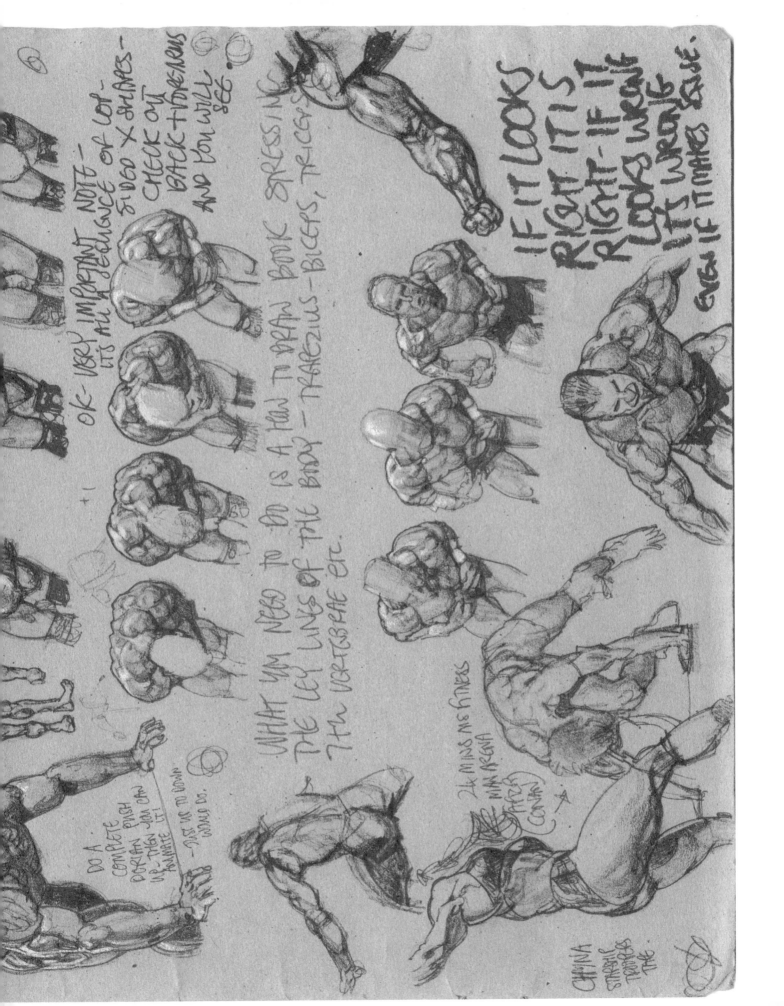

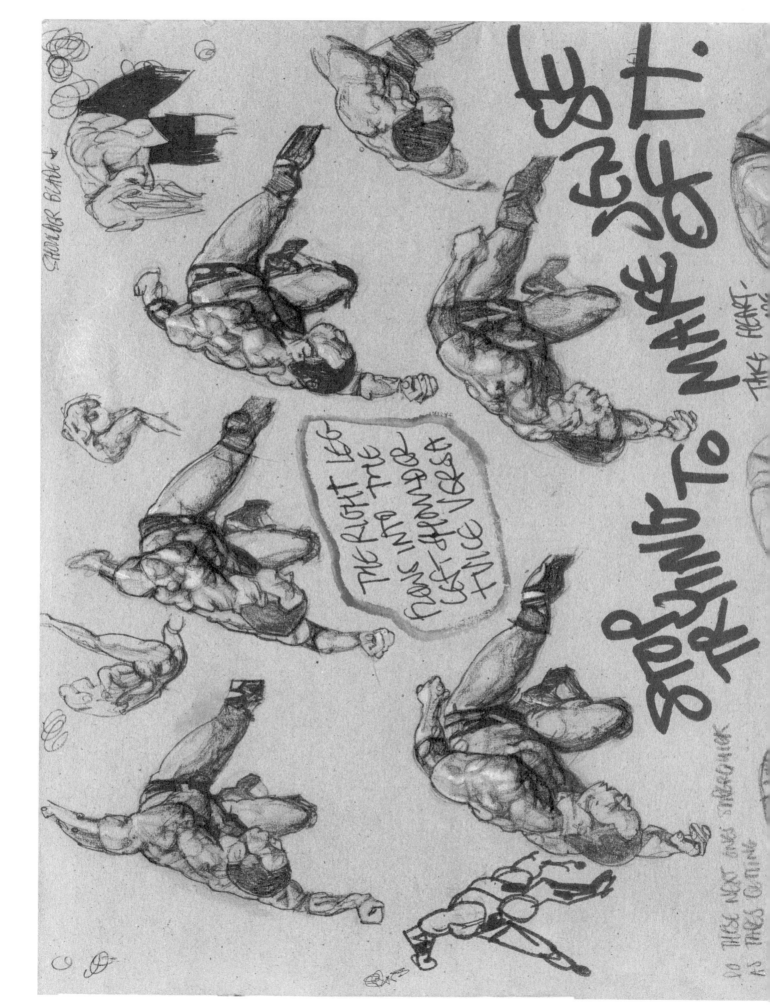

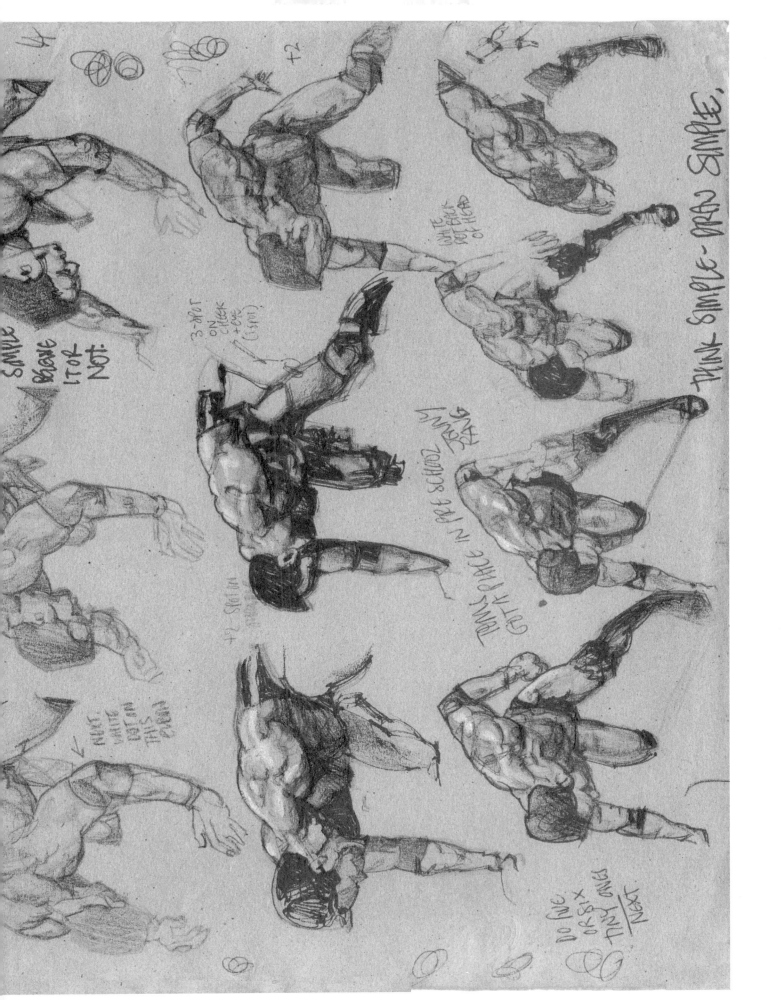

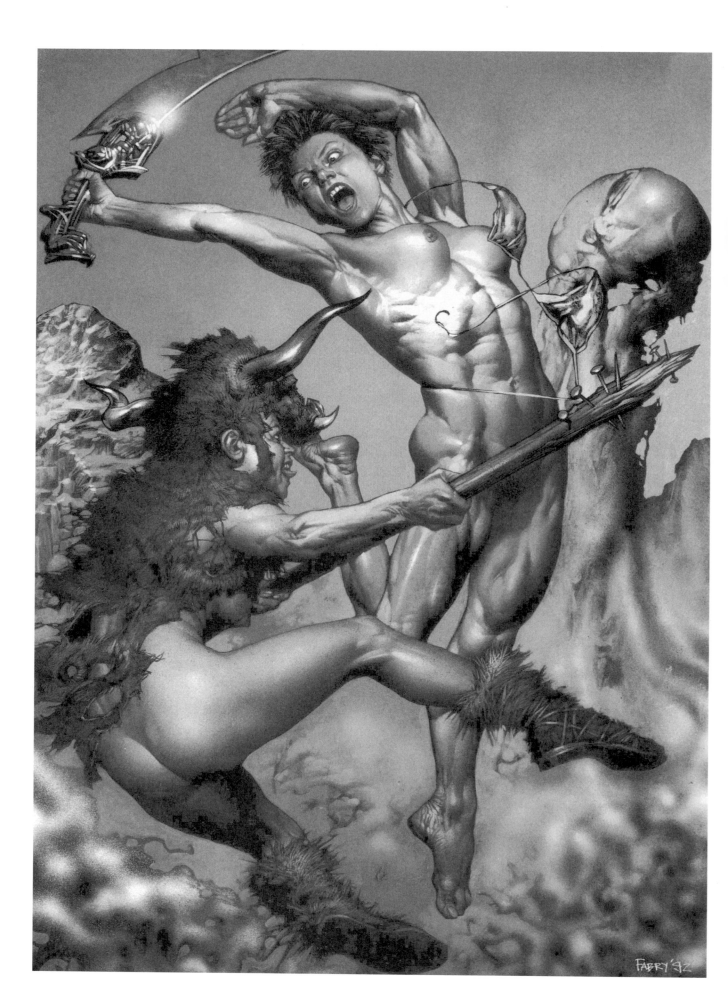

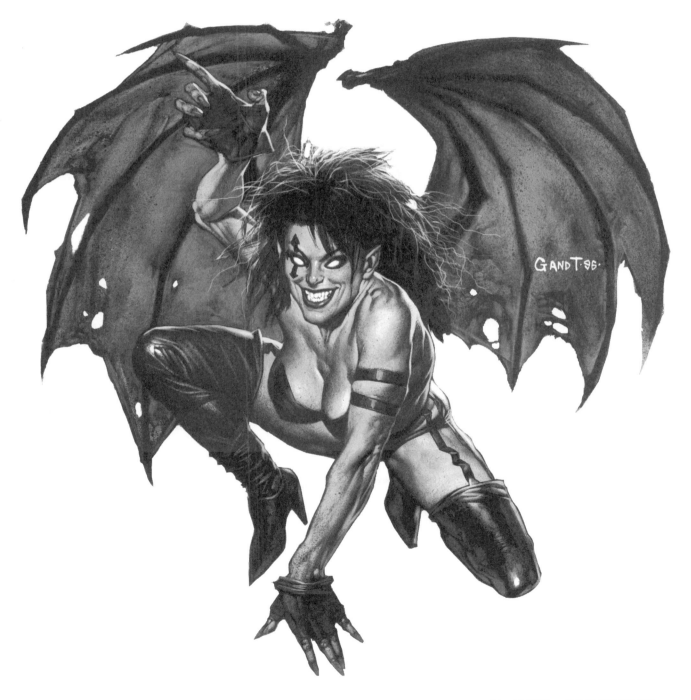

Glenn Fabry :: Artist

Glenn created his first professional cartoons at the age of 13 for an in-house newspaper at the Ministry of the Environment, U.K. While at college, at the age of 17, he made a fanzine with friends Steve Brown and John Mould called *Working Klass Superhero*. He also contributed a monthly comic strip, "Jackinblack," for The Stranglers' (punk rock group) magazine. Bryan Talbot saw this work and recommended him to writer Pat Mills as an artist for "Slaine" for the flagship English comic book weekly *2000 A.D.* Glenn worked at Fleetway Publications for nearly a decade on "Slaine," "Judge Dredd," and miscellaneous short strips and pin-ups.

In 1992 he painted covers for *Hellblazer* (DC Vertigo) during Garth Ennis and Steve Dillon's run. Garth and Steve used him as the cover artist on the very successful *Preacher* series (also for DC Vertigo) for which he won the Eisner award in 1995. A collection of these paintings, *Dead or Alive,* is still in print.

Glenn has worked for diverse clients, including Warner Brothers film division, *The Tatler* society magazine, Infogrames, Atari, and Marvel Entertainment. Most of his comic strip work has been reprinted as graphic novels, including *Slaine the King* and *Slaine: Demon Killer, Judge Dredd and Batman: Die Laughing, Thor: Vikings,* and *Howard the Duck* (with Steve Gerber and Phil Winslade). He contributed artwork to the *New York Times* best-seller *Endless Nights* by Neil Gaiman and *Bricktop* for Atomeka Publishing, which he cowrote with Chris Smith. He also painted *Outlaw Nation.* He's worked on numerous iconic characters, including The Incredible Hulk, Spider-Man, Wolverine, Batman, The Joker, Iron Man, Tank Girl, Captain America, Vampirella, Teenage Mutant Ninja Turtles, and Quentin Tarantino. And he's tattooed a bus driver.

Maria Paz Cabardo :: Art Director

Maria has worked in the role-playing games, computer games, comics, and advertising fields. She was creative director for Wizards of the Coast in Seattle, and prior to that she was art director for Mayfair Games in Chicago. As creative director for Smolhaus Design, her projects have included Pokemon Trading Cards and Magic: The Gathering, and she has designed for clients like The World Bank, Sprint, Microsoft, and many others. She is currently working as art director for creative services at DC Comics in New York City. She hates all forms of bigotry, especially towards art and its people, loves books, and can spell.

John Pinsky :: Graphic Designer

John is a freelance graphic designer and art director based in Brooklyn, NY. His waking life is occupied by design work for clients such as ISO, DC Comics, Ruder-Finn, Martha Stewart Omnimedia, Mad Dogs and Englishmen, Pronto Design, Columbia House, and Atlantic Records. The rest of his life is none of your business.

Acknowledgments

Special thanks to the following for providing help and support while the project was ongoing...

First and foremost, our families, for their patience. Mark Chiarello, Dale Crain, Dave Elliott, Nikki Fabry, Christina Graf, Anthony LaMolinara, Gary Leach, Jennifer Lee, Paul Levitz, Tony Luke, Deborah Meyer, Vic "Production boy" Pogi, and Will Simpson.